Images of Modern America

WACO

Images of Modern America

WACO

Eric S. Ames

ARCADIA
PUBLISHING

Copyright © 2016 by Eric S. Ames
ISBN 978-1-4671-1552-0

Published by Arcadia Publishing
Charleston, South Carolina

Printed in the United States of America

Library of Congress Control Number: 2015947364

For all general information, please contact Arcadia Publishing:
Telephone 843-853-2070
Fax 843-853-0044
E-mail sales@arcadiapublishing.com
For customer service and orders:
Toll-Free 1-888-313-2665

Visit us on the Internet at www.arcadiapublishing.com

To my father Patrick Ames (1953–2012), my mother Marsha Ames, my wife Amy, my daughters Sophia and Audrey, and the people of Waco

CONTENTS

ACKNOWLEDGMENTS

This is my second work on Waco history penned for Arcadia Publishing. The opportunity to document the amazing story of my adopted hometown has been one of the most rewarding experiences of my life, and it simply could not have come about without the help of many people. My deepest thanks and undying gratitude go to the following individuals: Bill Foster, former proprietor of the *Waco Citizen* newspaper; Julina Macy of the Greater Waco Chamber of Commerce; David Lintz, director of the Red Men Museum and Library; Robbie Rogers and the photographers of Baylor University Marketing and Communications; Baylor alumna Terri Barnes; Darryl Stuhr of the Baylor University Electronic Library; J.B. Smith, whose reporting on Waco's history for the *Waco Tribune-Herald* was immensely helpful for research purposes; and everyone whose passion for local history makes the creation of books like this possible.

INTRODUCTION

Like many American cities, Waco traces the start of the modern era to the end of World War II. The city certainly saw its share of postwar prosperity, as military investments and domestic production facilities pumped dollars and life into the local economy. Suburban developments housed a booming population. Downtown Waco sported shops, restaurants, and entertainment venues. Baylor University—which had weathered the difficult years of the Great Depression and the hardships of the world wars—was finally returning to normal, as veterans came to campus to take advantage of GI Bill funding.

Waco's history was forever altered on May 11, 1953, when one of the deadliest tornadoes in American history tore a devastating path through downtown. Part of a larger outbreak that wreaked havoc across a large swath of Central Texas, the Waco tornado killed 114 people, destroyed almost 200 businesses, damaged scores of buildings, and generated almost $500 million in property damage. The gaping physical scar the storm left through downtown was matched by an equally indelible trauma left on the collective psyche of every Wacoan alive that day, and decisions about how to rebuild, revitalize, and restore downtown would be a regular occurrence up to the present day.

The mid-century saw Waco struggling with many of the same challenges facing almost every American city of any size at that time: how to modernize without abandoning its roots, embrace change without compromising tradition, and approach issues like aging infrastructure, integration, and a shift of the population into neighboring suburbs. Two major developments in the 1950s and 1960s would forever change the city's physical (and sociopolitical) landscape. The first was the beginning of the urban renewal era in 1958. Initiated to combat a host of problems, it included addressing urban blight, including the razing of hundreds of derelict and decaying structures, examining problems of income inequality and challenges associated with integration, and renewing and renovating areas like the downtown core. Waco's focus on urban renewal tactics led to its inclusion in the federal government's Model Cities program in 1967. In all, more than $100 million in funds from the urban renewal project would shape Waco's urban fabric well into the 21st century.

The second major development in the mid-20th century came with the creation of Interstate 35. A major north-south artery on the federal interstate highway system, Interstate 35 made its inexorable way closer to Waco over the early 1960s. By the early 1970s, construction on the section through Waco was well underway. The gleaming ribbon of concrete and commerce brought increased traffic to the city, but it was not without its detractors. The thoroughfare's route cut a line like a surgical scar across established neighborhoods dating back to the earliest days of Waco history, and it severed areas of town like the Baylor University campus from the downtown corridor.

The 1980s saw Waco's population crest the 100,000 mark for the first time, and attractions like the Texas Sports Hall of Fame and the Dr Pepper Museum and Free Enterprise Institute

7

were founded, adding to the growing number of educational and recreational pursuits afforded to Wacoans and visitors alike. Waco's economy underwent many of the same booms and busts as other American cities during this period, with major events like General Tire's decision to close its Waco facility and lay off 1,400 employees highlighting the period's challenges.

By the 1990s, Waco had regained some of its economic stability, but an event that took place 10 miles outside the city limits would occur in the spring of 1993 that would forever brand Waco's name in the national consciousness. In February of that year, the Bureau of Alcohol, Tobacco, Firearms and Explosives (ATF) attempted to execute a warrant on a religious group called the Branch Davidians, whose Mount Carmel Center compound near the small community of Elk was believed to house illegal weapons. A raid led to a 51-day siege and, eventually, more than 80 dead, all played out on a national stage thanks to round-the-clock media coverage.

As more and more reporters converged on the scene, they were housed in Waco hotels, ate in Waco restaurants, and interviewed officials in Waco facilities. Their stories were filed with the byline "WACO, Texas," and in the time it took to submit a story to the newswire, the city was forever linked—incorrectly but irreversibly—with a national tragedy. Waco worked hard over the next two decades to distance itself from the pain and horror of the Waco siege, but its grip on the country was so deep, so pervasive that using the word Waco in popular media is enough to generate images of fire, fanaticism, and death to this day.

Waco's history in the new century has seen a renaissance in its downtown, with loft apartments, restaurants, boutiques, and entertainment venues once again giving life to the historic core of the city. Baylor University's national prominence in academics, Christian commitment, and yes, football continues to raise the city's name in discussions of the best universities in the country. During Pres. George W. Bush's tenure, he spent a good deal of time at his ranch in nearby Crawford, earning it the nickname the "Western White House" and bringing the city an opportunity to play host to world leaders, Secret Service security details, and Air Force One.

This book is intended to provide insight into the changes witnessed by the city of Waco and its citizens since the years immediately following World War II. It is not meant to be an exhaustive cataloging of those years; no single volume can adequately contain the hundreds of thousands of stories, large and small, that make up a city's full history. Any omissions readers may discover in this work may be attributed to authorial oversight.

The photographs in this book are derived from a number of sources. Major sources are my own collection of photographs (author's collection), the Bill Foster Photographic Archives (BFPA), the Greater Waco Chamber of Commerce photograph collection (GWCOC), and the Red Men Museum and Library (RMML).

One

BEFORE AND AFTER
THE TORNADO OF 1953

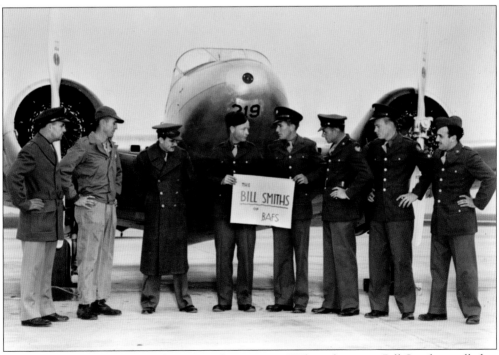

A note on this photograph, taken around 1943, says, "When the name Bill Smith is called at Blackland Army Flying School, Waco, Texas, eleven men snap to attention. In self defense they formed a 'Bill Smith' club." Eight of the "Bills" are in this photograph from the Office of War Information. (Library of Congress.)

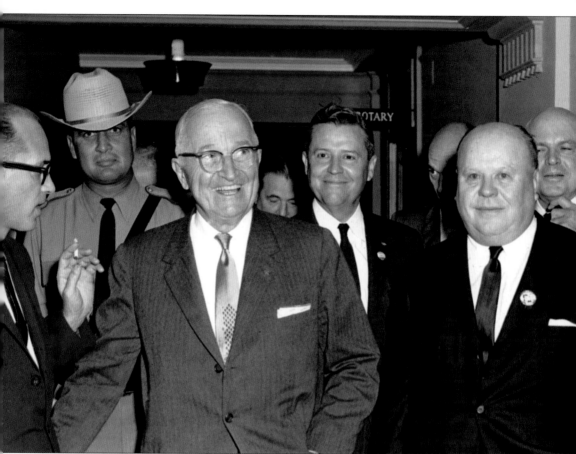

Waco photographer Jimmie Willis caught this photograph of Harry Truman (center) and his entourage as they made their way down the hall of the McLennan County Courthouse. Truman visited Waco in March 1947, the first sitting US president to do so, and received an honorary degree from Baylor University. He was quoted as saying, "It is with a real sense of gratification that I meet with you today on the beautiful campus of Baylor University in Waco. I congratulate you on the outstanding achievements of this great university during the one hundred and one years of its existence. I am sincerely grateful for the degree of Doctor of Laws that you have bestowed upon me, and I am honored to become a fellow alumnus of the distinguished men and women of this institution who have contributed so much to make our country great." (BFPA.)

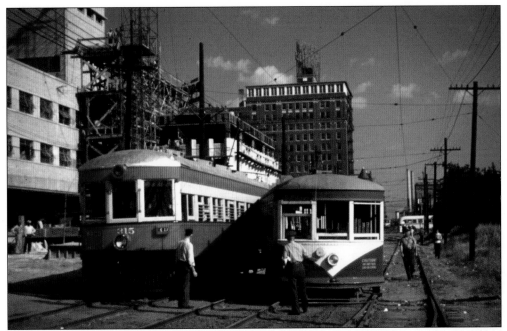

The Texas Electric Railway played a major part in the transportation of Wacoans seeking to travel to the cities of Dallas, Corsicana, and Denison. This is a rare color image of a Waco-bound car involved in an accident with a local line near the Hotel Jefferson in Dallas. The image is notable for capturing the Waco car's distinctive red-and-cream color scheme. (RMML.)

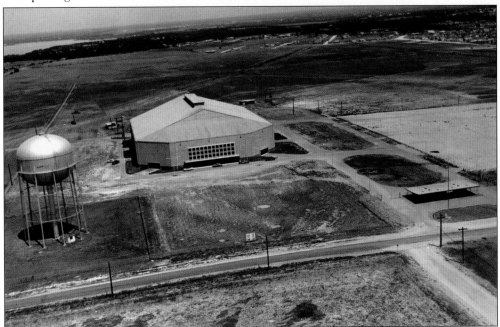

In the early 1950s, voters approved a bond to build an events center for Waco, and construction on the Heart o' Texas Coliseum was underway by 1952. This aerial photograph, probably taken in early 1953, shows the completed main building, a ticket building, and a parking lot. Later, additional show barns and livestock pens would be added. (RMML.)

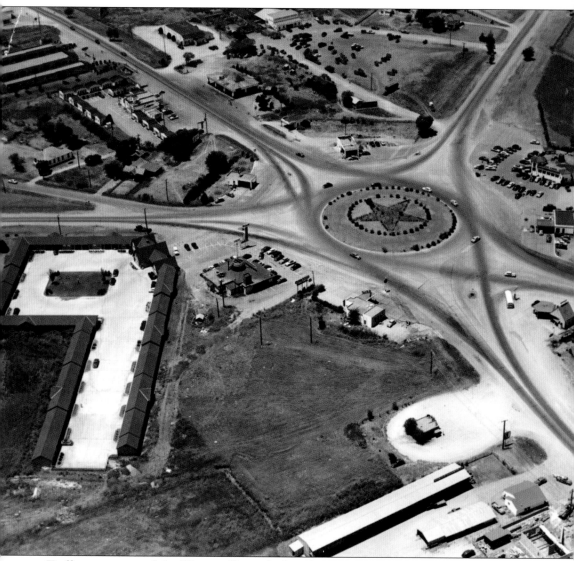

Traffic moves around the Waco traffic circle, long home to some of the city's most famous and enduring landmarks. This 1951 aerial photograph shows several of them, including Elite Cafe, built in 1941, at the top right. A young Elvis Presley ate at this location during his time in the Army when he was stationed at nearby Fort Hood in Killeen. The Elite remains open to this day, serving many of the same foods it has since its opening. At bottom is the Circle Lumber Co., still in operation today as Circle Hardware. The large complex at the left is a motor inn called the Tam O' Shanter Hotel Courts. Between the hotel and the circle is Bill Wood's XXX Famous Foods, remembered chiefly for a unique architectural detail: the large barrel that stuck up through its roof. (RMML.)

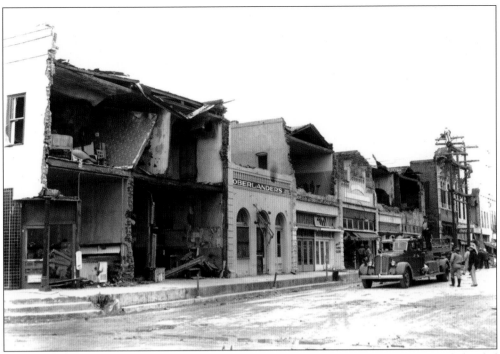

One of the defining moments in Waco's history came on May 11, 1953, when an F5 tornado leveled significant portions of downtown and killed 114 people. The Waco tornado delineates two distinct periods of the city's history: before and after. The street view of the destruction shows a block of businesses with extensive damage, including some that had been in Waco since the late 1800s. The aerial shot depicts just how extensive the tornado's swath of destruction was, demolishing entire blocks from downtown to the Brazos River. In all, almost 200 businesses were destroyed, and more than $400 million in damages were recorded. (Both, GWCOC.)

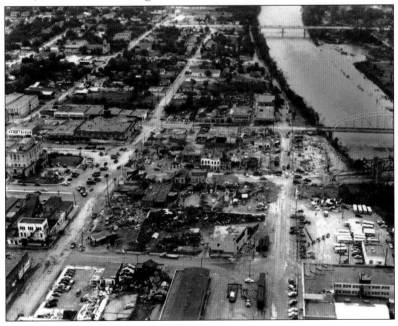

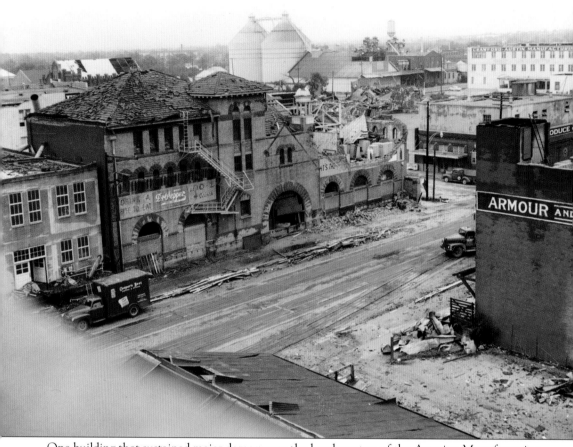

One building that sustained major damage was the headquarters of the Artesian Manufacturing and Bottling Co., home to Dr Pepper. Seen in the middle ground in this photograph, the building's upper floors were severely impacted by the storm's winds. The damage would be repaired, but visitors to the Dr Pepper Museum and Free Enterprise Institute can see the scar in the masonry that outlines the half-circle chunk revealed here. Other buildings in this photograph such as the Armour and Swift building, the Crawford-Austin Manufacturing building, and a block of commercial structures near the silos in the middle background were either damaged or later demolished. Note also the damage to the church in the upper left, which saw over half of its roof sheared off. (Dr Pepper Museum and Free Enterprise Institute.)

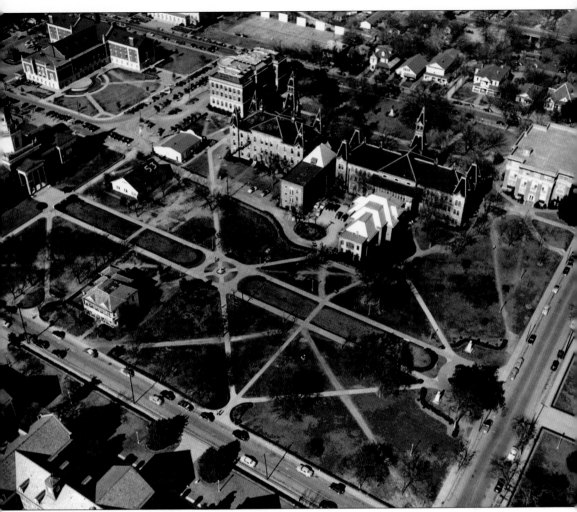

Baylor's core campus buildings are pictured here around 1954 as well as an area known today as Founders Mall. Pat Neff Hall, the main administration building, is seen at left. Old Main—with the years of recent graduating classes painted on its roof—and Burleson Hall are in the upper center, flanked at either end by Carroll Library (left) and Carroll Science (right). The white building at middle left once housed the art and home economics departments; the building with the number 53 on its roof was the band practice hall. Both have long since been demolished. Also gone are the houses at the upper right. Once used for student housing, they were demolished not long after this photograph was taken in order to make room for Morrison Constitution Hall (home to the Baylor Law School) and the Hankamer School of Business. (RMML.)

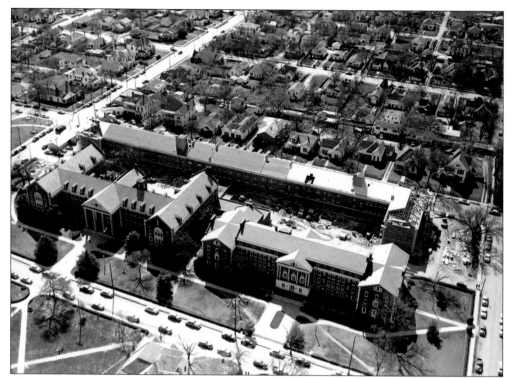

This 1954 aerial reveals some long-lost details about two areas of the Baylor University campus and its surroundings. The photograph above shows the nearly completed Allen and Dawson residence halls, situated behind two older dormitories, Memorial Hall (left) and Alexander Hall (right). What is notable about this photograph is the still-intact nature of the neighborhood behind the dormitories; single-family houses stretch for blocks off to the south of campus. Today, many of these homes have been demolished and replaced by multi-tenant condos and apartments. The image below shows Brooks Hall, named after legendary Baylor president Samuel Palmer Brooks. This photograph was taken around the time the 30-year-old structure was renovated to include air conditioning; it was demolished in 2006. (Both, RMML.)

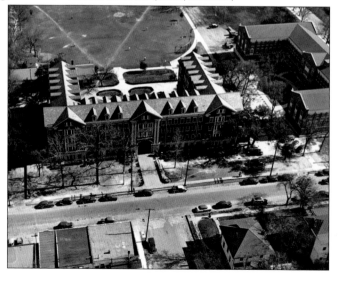

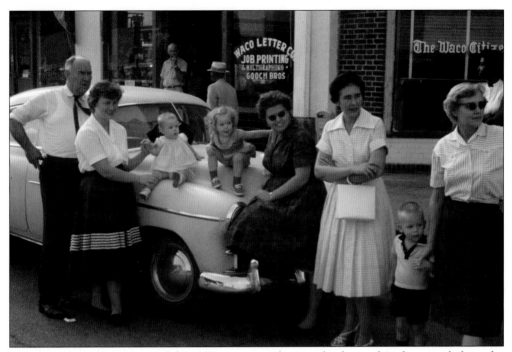

The downtown Waco scene of the 1950s is captured in vivid color in this photograph from the collection of Bill Foster. Members of the Foster family are gathered in front of the office of the *Waco Citizen*, the newspaper founded by Foster's father in 1944. The *Citizen* would continue to operate under the leadership of the Foster family for seven decades. (BFPA.)

The iconic structure known as the Cottonland Castle—which gave the surrounding area its name, Castle Heights—is front and center in this c. 1955 aerial photograph. The castle was built over the course of two decades beginning in the 1890s; today, a scholar from Oxford University owns the property and is in the process of restoring it. (RMML.)

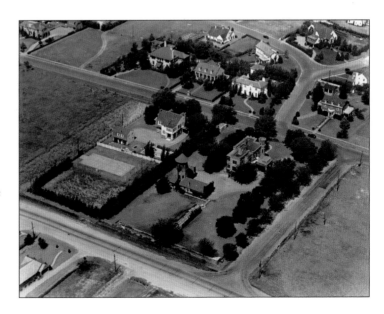

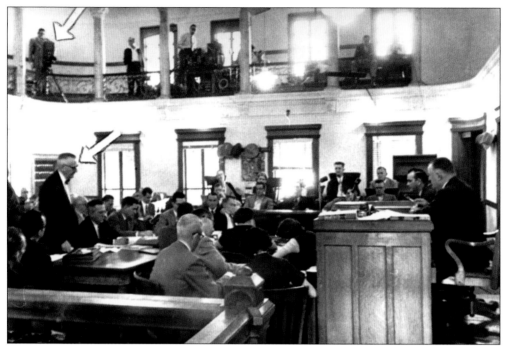

History was made in December 1955 by Waco's KWTX television station when it became the first to televise a live court proceeding from judge D.W. Bartlett's 54th District Court. The trial of Harry Washburn of San Angelo—who was accused of killing his mother-in-law with a bomb planted in her car—was moved to Waco due to extensive media coverage. The trial was broadcast without commercials or interruptions for a week. These United Press International photographs show the courtroom with its original second-floor balcony, where a lone KWTX cameraman was positioned out of sight of the jury. The arrow in the photograph above points to defense lawyer C.S. Farmer; in the image below, it indicates the defendant, Harry Washburn, who was found guilty and sentenced to life in prison. (Both, RMML.)

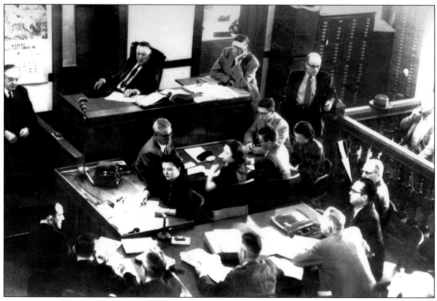

Two

THE 1960s AND URBAN RENEWAL

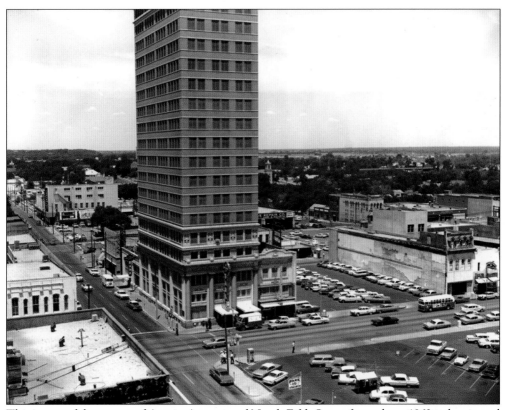

This image of the corner of Austin Avenue and North Fifth Street from about 1962 is dominated by the Amicable (ALICO) Building. Within a few years, it would become the lone structure standing on its block; the buildings to the right (including the Victorian-era structure across the parking lot) were leveled for additional parking. (GWCOC.)

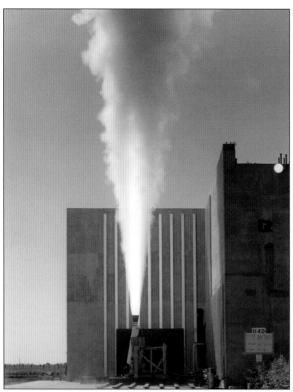

Following World War II, private companies partnered with the US government to study and improve upon rocket technology created by Nazi scientists in the 1940s. The Rocketdyne Division of North American Aviation maintained a testing facility in nearby McGregor, where an engine test was captured in this December 11, 1964, photograph. (GWCOC.)

These impressive limestone and wrought iron gates once stood at one of the many roads providing access to Cameron Park, one of the largest urban parks in the United States, at more than 400 acres. The gates pictured here in the early 1960s are believed to have stood at the Robin Road entry to the park, but they have since been demolished. (GWCOC.)

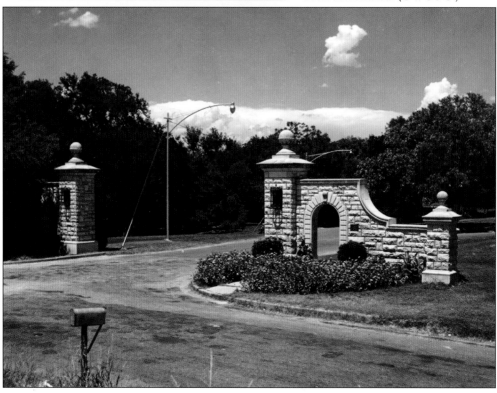

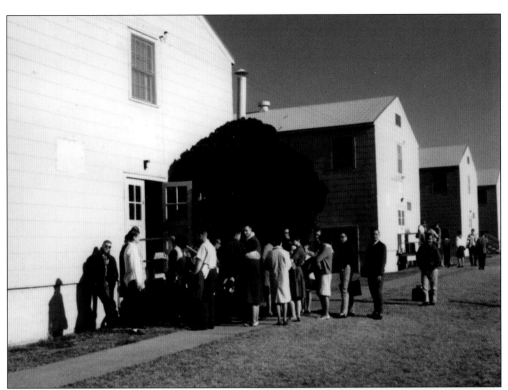

McLennan Community College—one of
the first colleges in the United States to
incorporate the word *community* into its
name—opened on the grounds of James
Connally Air Force Base in 1965. This
photograph of students lined up outside
a campus building as they wait to register
for classes is a rare color photograph of
the school's earliest days. (McLennan
Community College Archives.)

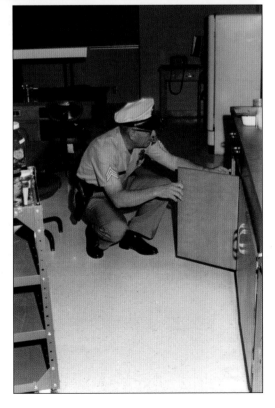

With a sprawling new campus
accommodating hundreds of students in the
late 1960s, McLennan Community College
(MCC) had expanded dramatically since
its founding on the Connally Air Force
Base grounds. As part of its commitment to
student safety, MCC hosted elaborate drills
in which public safety officers performed
tasks like sweeping for explosives, as seen
in this late-1960s photograph. (McLennan
Community College Archives.)

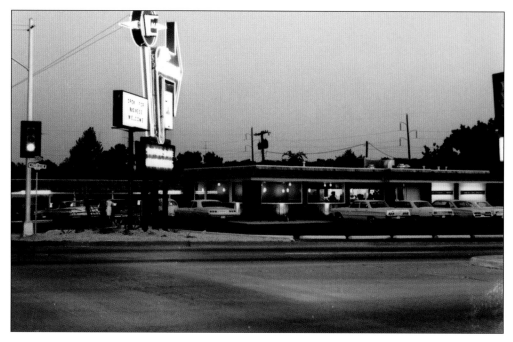

A veritable fleet of mid-century automobiles is parked in front of Kim's Diner, which opened in 1965 at Waco Drive and North Twenty-Sixth Street. Featuring a landmark neon sign—with its iconic malt cup and large pink arrow—the location allowed diners to eat indoors or have food delivered to their vehicles as they sat in a covered parking area. Inside, members of Kim's kitchen crew grilled up hamburgers, chicken-fried steaks, and daily blue-plate specials for hungry diners drawn to the restaurant known for its down-home fare and fast, friendly service. The building is still standing today, doing business under new ownership as Kim's 1950s Diner. (Both, BFPA.)

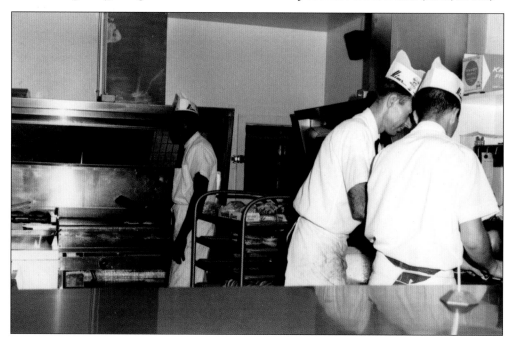

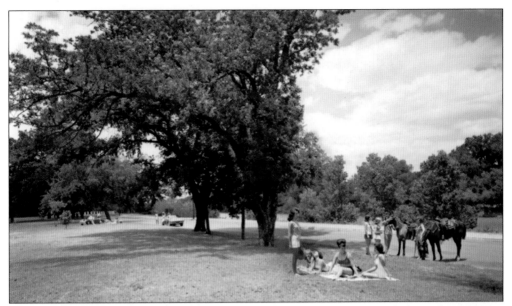

Featuring horseback riders, convertibles, and sunbathers, this photograph from about 1965 is believed to be part of a series of staged photographs taken to promote Cameron Park. The Brazos River, a defining feature of the park's geography, is visible in the background as it winds through the Pecan Bottoms section of the park. (GWCOC.)

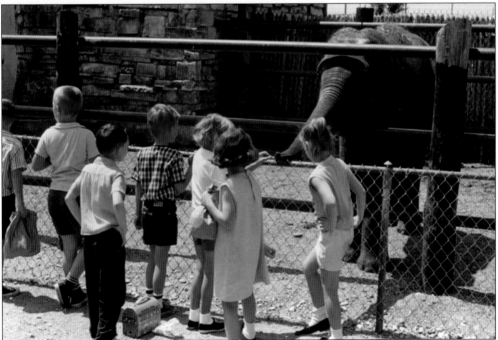

Established in 1955, the Central Texas Zoological Park (usually referred to by its nickname, the CenTex Zoo) featured both native fauna and exotic animals, like this baby elephant being fed by a group of schoolchildren in the early 1970s. The zoo operated near the Waco Regional Airport until it relocated to Cameron Park in 1993, where it was rechristened the Cameron Park Zoo. (GWCOC.)

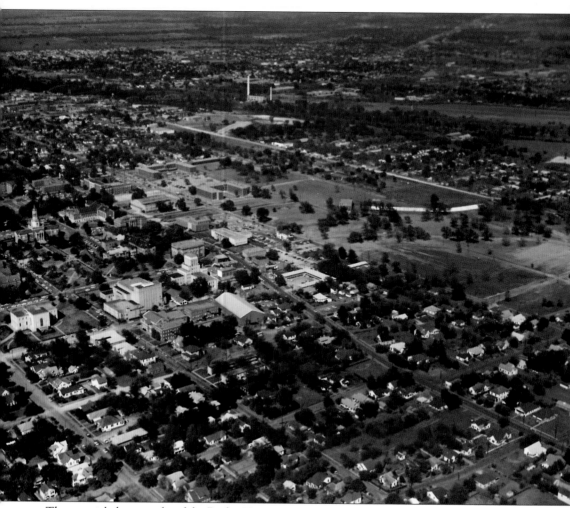

These aerial photographs of the Baylor University campus were taken in the mid-1960s during the time of the urban renewal project that would dominate the city's landscape for decades. Through a series of political maneuvering, purchases, and imminent domain–style acquisitions, the land between the northern edge of campus and the Brazos River would be added to campus by the mid-1970s. The exposed drainage ditch at middle right in each photograph became an underground

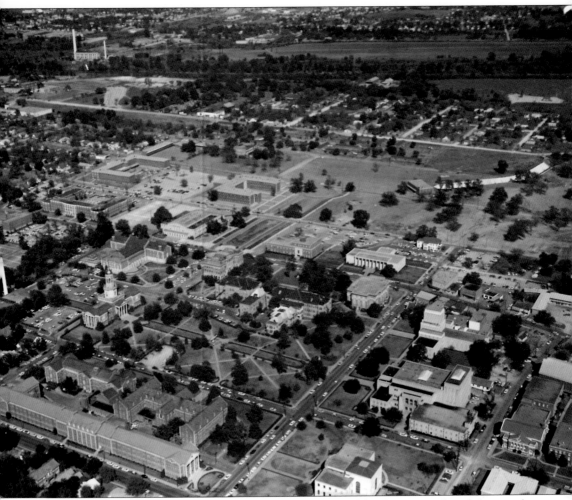

creek. The move would be controversial for decades because of the decision to demolish several blocks' worth of homes between the campus and the Brazos River (at top). In time, this area became home to Moody Memorial Library, several dormitories, the Baylor School of Law, athletics facilities, and in 2014, a bridge connecting campus to McLane Stadium. (GWCOC.)

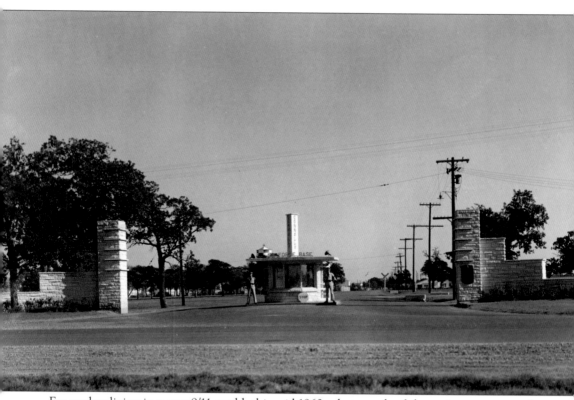

For readers living in a post-9/11 world, this mid-1960s photograph of the main entrance to the James Connally Air Force Base shows an installation with a seemingly minimal amount of obvious security measures. There are no barricades, no retractable gates, no spike strips, and only two armed guards stationed at a security booth. This image was taken shortly before Connally was closed in 1968. Although its closure meant a temporary drag on the local economy, the base found new life as home to Texas State Technical Institute and, briefly, McLennan Community College, before the school opened its current campus near the Bosque River. In recent years, the landing strips at the former base accommodated takeoffs and landings for Air Force One during the presidency of George W. Bush, whose ranch in Crawford is only a few miles from Waco. (GWCOC.)

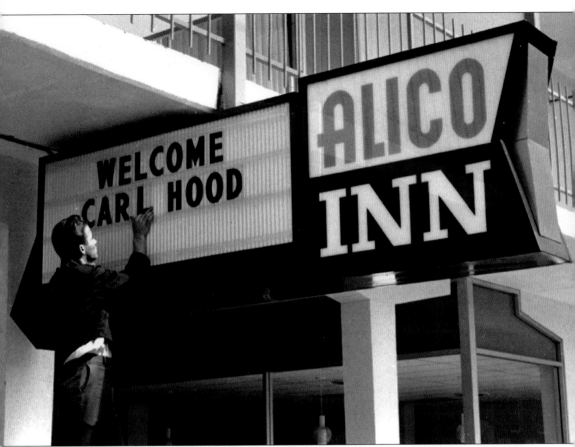

An employee of the Alico Inn adjusts the wording on the hotel's signage in this late-1960s image. The hotel, which contained 115 rooms and a restaurant, was part of a mid-century attempt to breathe new life into the Amicable Building by creating a complex called the ALICO Center. In the wake of the Roosevelt Hotel's closure and subsequent conversion into a retirement center, city business leaders saw the need for additional hotel rooms and convention facilities in downtown. In the mid-1960s, these facilities were built and attached to the original 1911 skyscraper, Waco's tallest building, which received updated modernist cladding on its lower floors to match the new construction. The complex was only moderately successful, however, and by the late 1990s, the convention center and hotel portion of the ALICO Center were demolished, leaving only the parking garage attached to the original skyscraper. (GWCOC.)

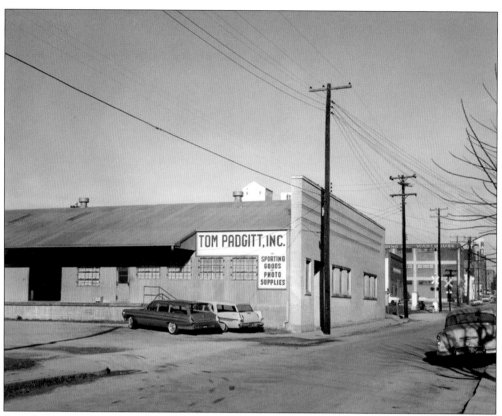

Founded in 1867 as a purveyor of leather goods, Padgitt's was located in downtown Waco for many years; first on Bridge Street, then in a multistory location that was destroyed by the 1953 tornado. The downtown warehouse location shown in this early 1960s photograph was its home until it moved to Franklin Avenue in the 1970s. Padgitt's closed its doors for good in 2014 after 147 years in business. (GWCOC.)

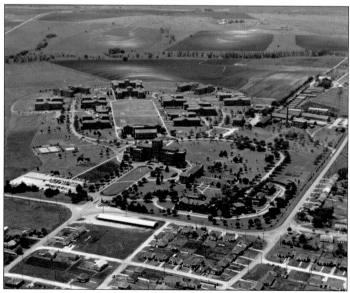

The Waco Regional Veterans Affairs Hospital is seen in this early 1960s aerial photograph. The campus, which included more than a dozen buildings, was on the outskirts of the city and bordered by fields. In the 1930s, the hospital operated hundreds of acres as a working farm that included orchards, vegetable gardens, and fields of crops. (GWCOC.)

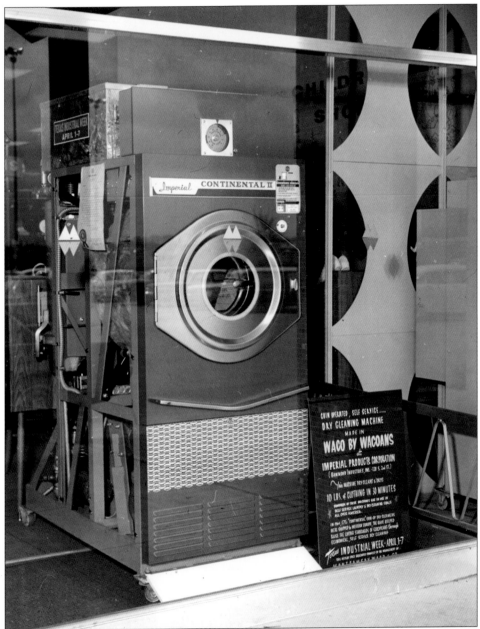

During the mid-1960s, the chamber of commerce guided Waco's participation in Texas Industrial Week, a showcase of products and companies based in the state. Businesses all over town contributed unique window displays or tables in public buildings like the downtown library that showcased their industrial output and how it impacted the state's economy. This display from Industrial Week 1965, donated by Montgomery Ward and Co., promotes a "coin operated, self service" dry-cleaning machine made by Imperial Products of Waco, located at Hammond Industries on South Second Street. According to the display, the machine was capable of dry cleaning and drying 10 pounds of clothing in 30 minutes. The sign also says that in the previous year, 175 such units were shipped to Western Europe to help "raise the living standards of Europeans through economical, self service dry cleaning." (GWCOC.)

With the exception of the tallest buildings in the background, all of the structures shown in this late-1960s photograph have since been demolished, including the entire block on the left, beginning with the Rambler dealership and running almost all the way to the Hotel Raleigh. That block has since been replaced by parking lots. (GWCOC.)

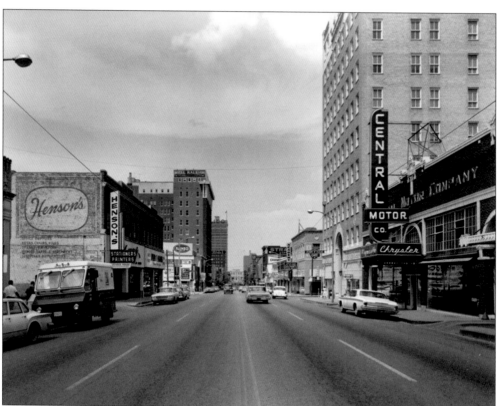

A view to the north down Austin Avenue captures the street in its mid-1960s glory. Of the two sides of the street, the western side (left) fared far worse than the eastern over time; since this photograph was taken, every building between the Raleigh Hotel and the viewer has since been demolished, while the buildings on the right mostly survive intact. (GWCOC.)

30

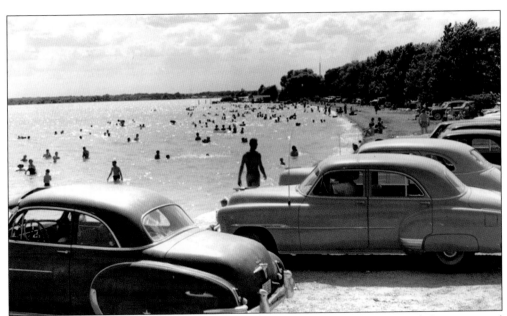

In addition to being a 100-year supply of water, Lake Waco has long provided recreational opportunities to area residents, taking the form of fishing, waterskiing, boating, and sunbathing. These photographs, taken in the late 1960s, show crowds enjoying a summer day at one of the lake's beaches. Parking in those days meant pulling one's Rambler, Chevrolet, or Ford onto the beach and putting a blanket out on the sand right next to it. The lake in its present form was created in 1958 by a dam across the Bosque River, the ground-breaking ceremony for which was presided over by Lyndon B. Johnson, then representing Texas in the US Senate. (Both, GWCOC.)

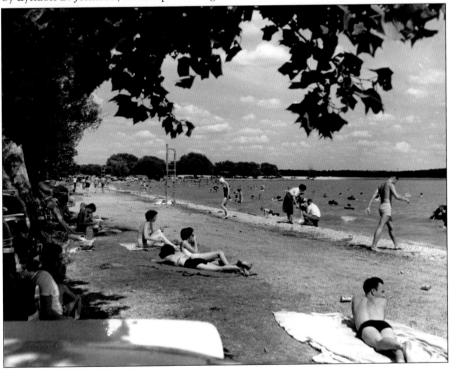

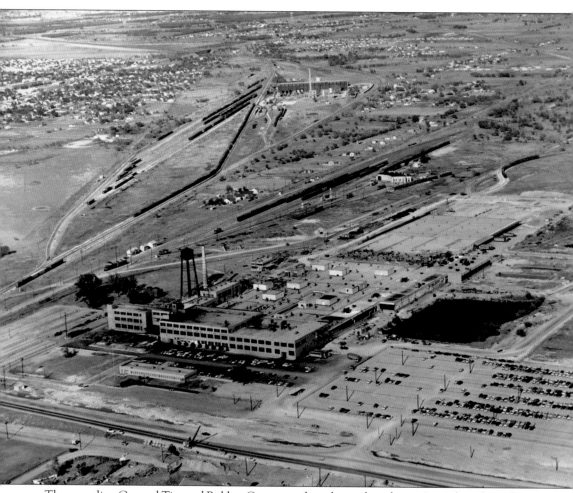

The sprawling General Tire and Rubber Company plant, located on the city's northern boundaries near the suburb of Bellmead, employed hundreds of people at the time of this aerial photograph, about 1965. Its extensive complex churned out untold thousands of bias-ply tires after World War II, and it reached its peak employment of more than 1,400 by the mid-1980s. The facility closed in 1985, and its buildings sat vacant for decades until they were acquired by Baylor University and transformed into a high-tech collaborative research facility in 2013. The large complex in the background—with the white smokestack and surrounded by railroad spur—is the Missouri, Kansas & Texas Railroad (MKT or "Katy") division locomotive repair works. Note also the white roundhouse in the middle distance, used for making repairs to locomotives. (RMML.)

An official with the Texas Highway Department presents an update to the planned route of Interstate 35 through McLennan County in this May 1966 photograph. While Interstate 35 would become a major boon to Waco in ensuing decades, its creation and location through the heart of several established neighborhoods were a source of contention during the highway's planning phase. (GWCOC.)

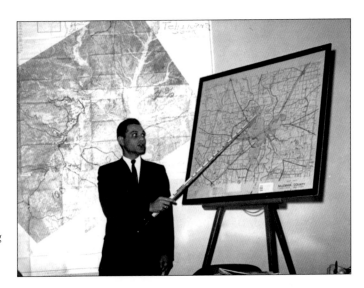

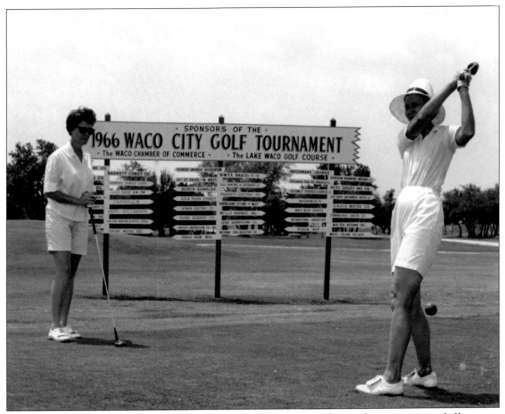

Waco's generally temperate climate makes it an ideal location for outdoor activities of all stripes. This photograph of participants in the 1966 Waco City Golf Tournament shows the event's long list of sponsors, including long-lost favorites like the Waco Italian Village, Dutchman's Lounge, Monnig's, and the Shelby Music Company. (GWCOC.)

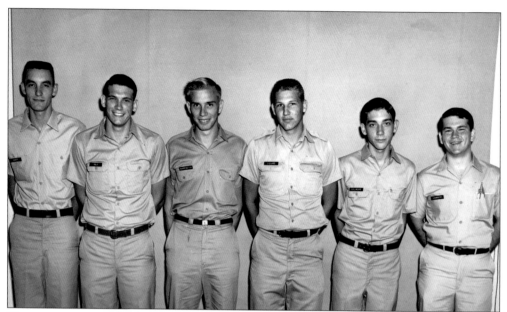

These men comprise the first class of police cadets, pictured here in June 1966. Pictured here from left to right, Walter Scott, Donald Odle, Carl Barrington, Donald Lillard, Monroe Kelinske, and Dewayne Chambers were the first young men to participate in the program that would eventually graduate dozens of young people. (Waco Police Museum Archives, Baylor University Libraries Digital Collections.)

Judging by the way some of its members' hair is decidedly mussed, it appears to have been a windy day in the spring of 1967 when the first class of McLennan Singers gathered for a group photograph on the grounds of McLennan Community College, then housed at James Connally Air Force Base. (McLennan Community College Archives.)

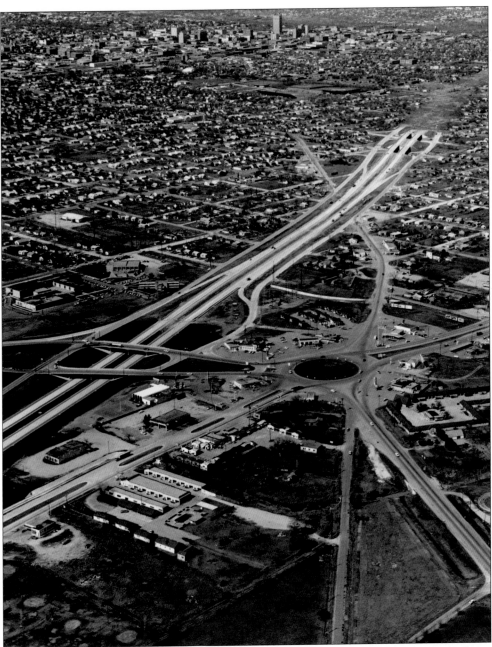

The gleaming concrete dividing line in this January 1967 aerial is Interstate 35, a superhighway built through town during the transformative days of urban renewal. The highway, which was constructed in sections moving northward from Austin, is pictured ending in a dramatic dead end at the overpasses for Seventeenth and Eighteenth Streets. Dirt work for the next section can be seen extending off toward the upper right of the photograph. Downtown looms in the far distance, and in the foreground is the Waco traffic circle, a meeting point for three separate highways. Near the overpasses for Valley Mills Drive—extending to the left from the circle—is the campus of University High School, which was demolished in 2014. The campus was rebuilt farther south on Interstate 35 near New Road. (RMML.)

These photographs were taken in 1968 as part of a promotional package for Lions Park, a local attraction operated by the Waco Founders Lions Club. Featuring a carousel, carnival rides, miniature golf course, and a miniature train that circles the park's grounds, Lions Park has been a fixture of local children's entertainment for more than a half century. (GWCOC.)

Three

THE 1970S AND 1980S

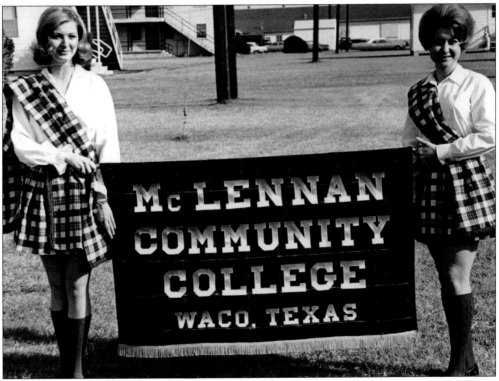

Two Highlassies—the female equivalent of the Highlander, McLennan Community College's official mascot—are seen wearing the official MCC plaid tartan at the college's early location at Connally Air Force Base. The photograph, believed to date to 1966, is one of the earliest showing coeds wearing their school spirit. (McLennan Community College Archives.)

Waco's suspension bridge opened as a toll thoroughfare in 1870, and over the past century and a half, images of its twin towers and mighty cables have become synonymous with the city itself. The city's official flag features an illustration of the bridge, and a song by country artist Billy Walker called "Cross the Brazos at Waco" references the Chisholm Trail, which crossed the bridge. The renovation and updating of the structure was even chosen as Waco's official American bicentennial project, completed in 1976. In 1966, a special medallion was created to pay tribute to the centennial of the bridge's chartering in 1866. Bearing the phrase "First across and still across," an image of the bridge on one side, and an image of the Chisholm Trail's route on the reverse, the medallion is seen here in 1970, on the 100th anniversary of the bridge's official opening in 1870. (GWCOC.)

Two historic homes operated by Historic Waco Foundation (HWF) are featured here, each with interpreters wearing period-appropriate costumes. The visitors to Fort House in the black-and-white 1978 photograph are greeted by staff offering information about the home's unique features. In the color photograph of East Terrace—the common name for the J.W. Mann home—a group of women gathers for tea in the shade of one of the home's many large oak trees. The restored homes of HWF preserve magnificent examples of the kinds of houses built in the 1800s by Waco's most prominent citizens. (Both, GWCOC.)

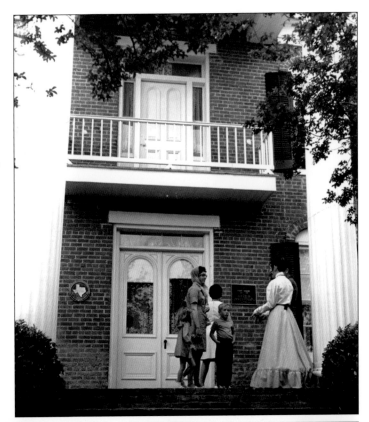

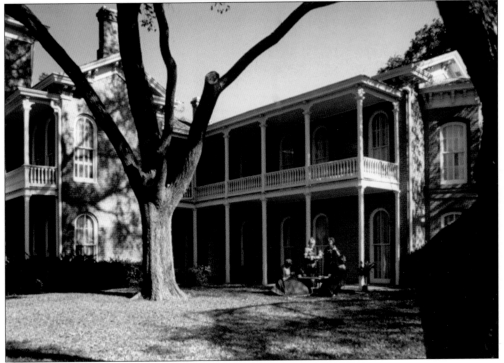

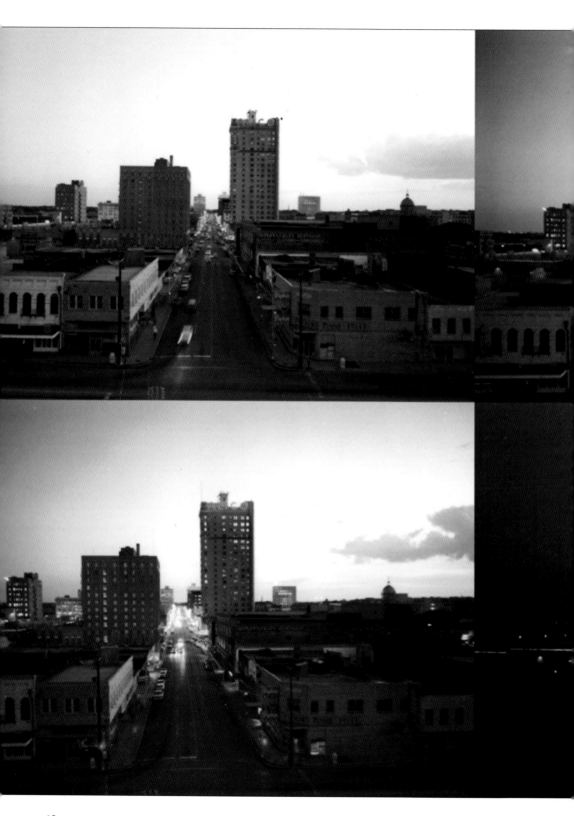

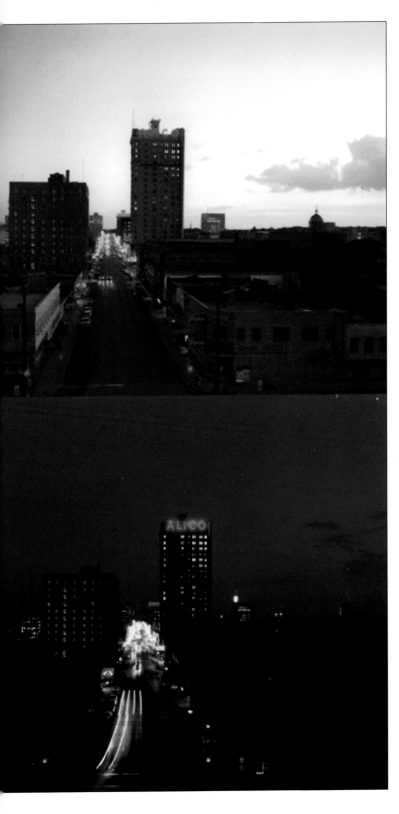

An enterprising photographer for the chamber of commerce took this series of photographs as the sun set over Austin Avenue in the mid-1970s. The ALICO Building dominates the skyline as it has since its completion in 1910, and the neon lights of its instantly recognizable signage come to life as the sky darkens. The row of mostly commercial buildings, including the corner Pipkin Drug Store, has since been demolished but this image shows off the architectural styles of almost 75 years of continuous downtown development. The timed exposure of the lower-right frame shows the lights of the most heavily trafficked portion of the avenue, which included theaters, shopping, and nightlife venues. (GWCOC.)

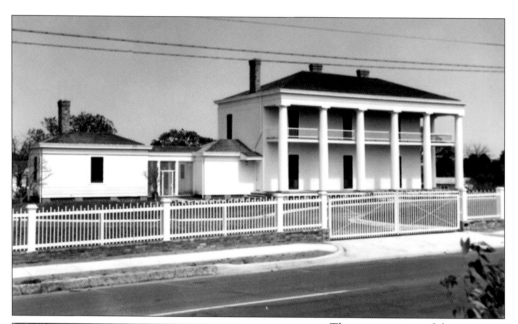

The construction of the interstate highway near Fourth Street prompted local preservationists to save the Earle-Harrison House, a grand antebellum home. The restored home, seen here in its relocated and current location at Fifth Street and Brook Avenue, opened to the public in 1970. This is thought to be one of the earliest known photographs of the home after its restoration. (GWCOC.)

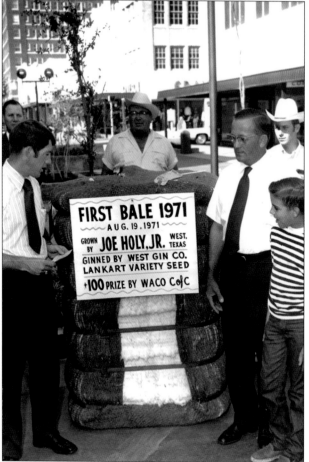

FIRST BALE 1971
AUG. 19, 1971
GROWN BY JOE HOLY, JR. WEST, TEXAS
GINNED BY WEST GIN CO.
LANKART VARIETY SEED
+100 PRIZE BY WACO C of C

Civic organizations and the chamber of commerce would frequently stage contests, promotions, and other activities to drive Wacoans to downtown, like this promotion involving the first bale of cotton ginned for 1971. Joy Holy Jr., the lucky West, Texas, grower of 1971's first bale, received the honor of having his cotton displayed in the downtown pedestrian mall and a cash prize of $100. (GWCOC.)

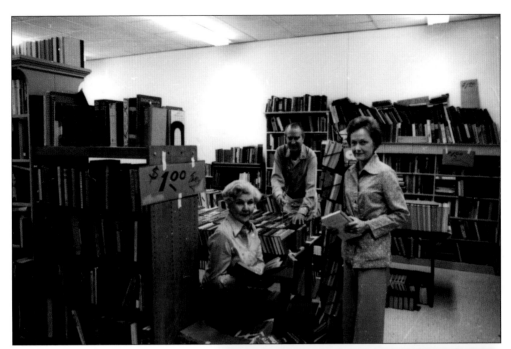

The Friends of the Waco-McLennan Library book sale has been an annual tradition since 1962. The event serves as a major fundraiser for the group, and its arrival each fall is eagerly anticipated by book lovers across the Waco area. Three volunteers are pictured here around 1975 prepping tables with hundreds of soon-to-be-sold titles at the downtown library branch. (BFPA.)

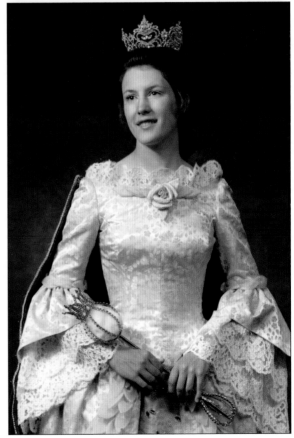

One of Waco's most enduring traditions is the Cotton Palace Pageant, an annual affair in which young women dress in elaborate gowns and stage a production for the public. The first Cotton Palace Pageant was held in the 1920s, and modern versions closely resemble debutante balls. Faye Trippet is pictured here in 1976 with all the accouterments befitting her status as Cotton Queen. (BFPA.)

Traffic crosses the steel bridge that runs alongside the suspension bridge in this 1978 photograph. The suspension bridge was closed to motor vehicles in 1971. The neighboring bridge was eventually demolished, leaving only its pilings in the river. Today, Baylor students try to fling tortillas from the suspension bridge onto those pilings in the rite of passage known as tortilla tossing. (GWCOC.)

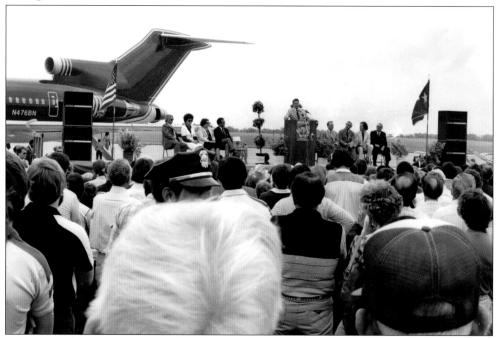

Just prior to that summer's Republican convention, future presidential candidate Ronald Reagan pays a visit to Waco in April 1980. Reagan delivers a stump speech to the crowd from a platform erected on the tarmac at the Waco Regional Airport, just feet away from the jet in which he arrived. (BFPA.)

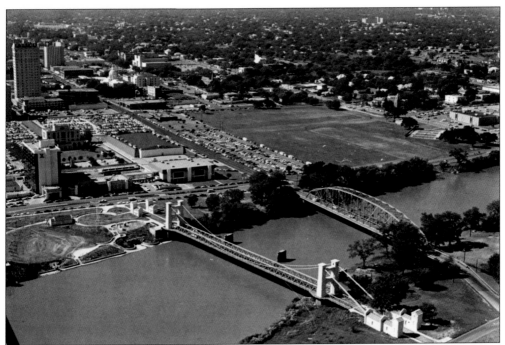

This aerial photograph of the Brazos River corridor was taken by John Bennett on October 28, 1981. It captures the nascent development of Indian Springs Park (on the downtown side of the suspension bridge) and the large empty field that once held large portions of the Reservation, Waco's legal red-light district, which was cleared out by the US Army in 1917. (BFPA.)

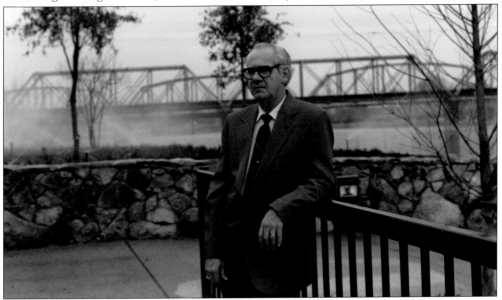

Old school newspaperman, indefatigable Waco booster, and one of the hardest working men in town, Bill Foster—publisher and guiding light behind the *Waco Citizen*—is seen here at the Brazos River river walk in an early 1980s photograph. Foster was active in the Waco social scene for decades, participating in the Miss Waco Pageant, Lions Club, and First Methodist Church, among many other organizations. (BFPA.)

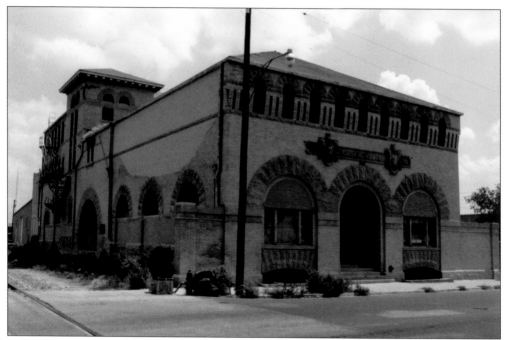

Major developments in the life of the former Artesian Manufacturing and Bottling Co. building took shape in the late 1980s when a group of supporters sought to bring new life to the semi-abandoned space at South Fifth Street and Mary Avenue. The top photograph shows the building as it looked after years of inactivity. Below, this 1988 photograph shows an event celebrating the building's transferal of ownership from the Dr Pepper Snapple Group to local citizens who dreamed of turning it into a museum celebrating the history of Dr Pepper and its Waco roots. (Both, Dr Pepper Museum and Free Enterprise Institute.)

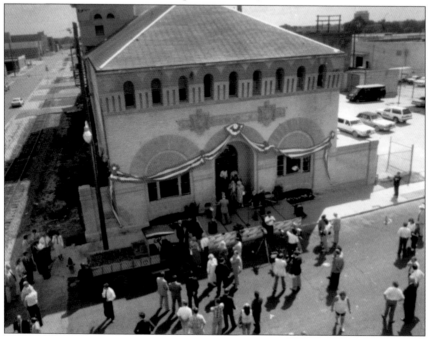

Dallas Cowboys head coach Tom Landry (center) was honored at the HOT (Heart of Texas) Boy Scout Distinguished Citizen Award Dinner on May 14, 1985. Landry drew a large crowd, despite appearing without his trademark fedora. He is seen here signing autographs for local Boys Scouts while wearing the Distinguished Citizen Award for 1985. (BFPA.)

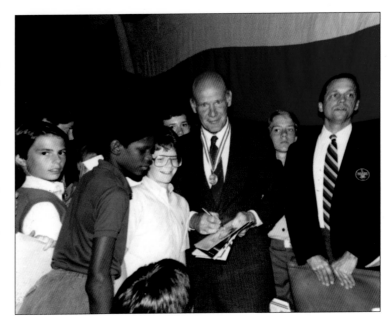

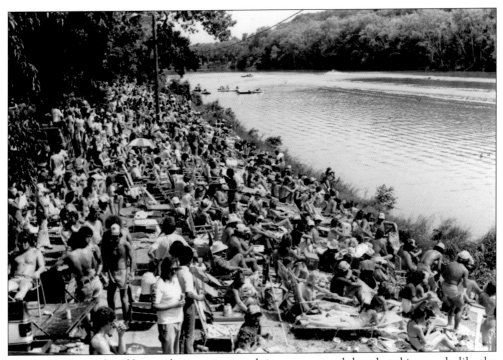

The Brazos River played host to boat races several times a year, and they drew big crowds, like the one pictured here around 1985. The river's role in Waco's history has long been a series of give-and-take transactions. From devastating floods to source of life-giving drinking water and a place for high-speed recreation, the Brazos's steady presence has long defined life in the city. (BFPA.)

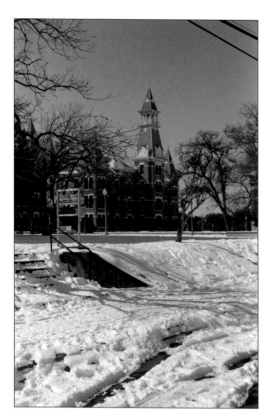

A major snowstorm hit the Waco area between January 11 and 13, 1985, and while snowfalls like this are rare in Central Texas, the National Weather Service lists this particular event as a significant weather storm, one which longtime Wacoans can recall with ease. Senior Baylor student Terri (Hurley) Barnes captured some snowy scenes around campus, including these photographs of a snow-covered Fifth Street running in front of Old Main/Burleson Quadrangle (left) and water frozen mid-fall on the Vara Faye Daniel Fountain. Dubbed the "fish ladder" by students, the fountain was demolished in 2003 after engineers discovered evidence of significant structural damage. (Both, Terri Barnes.)

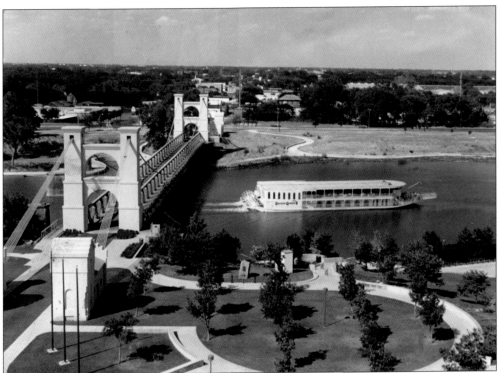

The paddle wheeler *Brazos Queen II* heads down the Brazos River in this series of photographs from August 17, 1986. In the photograph above, the vessel is progressing downstream just past the suspension bridge. The far bank of the Brazos River shows a complete lack of vegetation as opposed to the manicured lawns of Indian Springs Park. In the image below, the *Queen* is approaching a railway trestle formerly owned by the Union Pacific Railroad. Since it was abandoned, it has become a popular spot for photographers. The white warehouse at the right, once home to a machine tool company, has since been demolished. (Both, BFPA.)

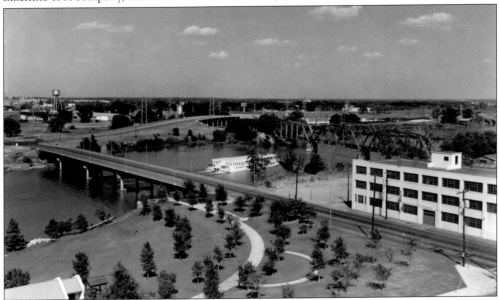

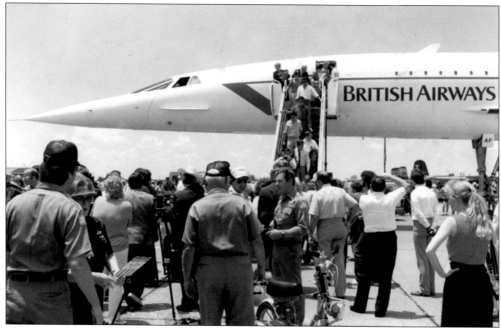

A British Airways Concorde, a supersonic jet that flew between London, Paris, and New York City, sits on the tarmac at the TSTC (Texas State Technical College) airfield in this June 1986 photograph. The Concorde was a major attraction at the show, drawing crowds of onlookers eager to tour a jet capable of achieving Mach 2.2. (BFPA.)

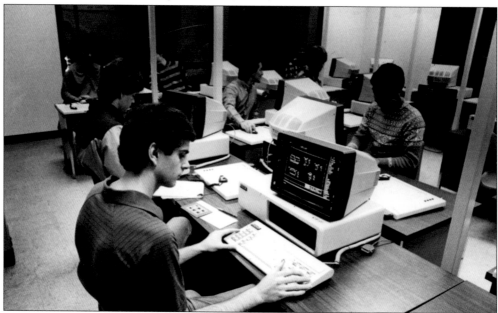

The Waco campus of Texas State Technical College (originally Texas State Technical Institute) has been on the cutting edge of technology-focused education since the late 1960s. It was the first school in the United States to offer an associate of applied science degree in laser electro-optics technology. Students are pictured here using computers to complete their coursework around 1986. (BFPA.)

The Ferrell Center, an iconic part of Baylor University's campus, was erected in 1988. Seen under construction in this December 1987 photograph without its immediately recognizable golden dome in place, the building was designed by the architectural firm of Crain & Anderson. The first public event staged in Baylor's Ferrell Events Center was a political rally for Pres. Ronald Reagan held on September 22, 1988. Reagan is pictured here surrounded by well-wishers, including Baylor University president Herbert H. Reynolds, seen at the podium. President Reagan was given a green jacket emblazoned with the phrase "Our Bear in the White House." (Both, BFPA.)

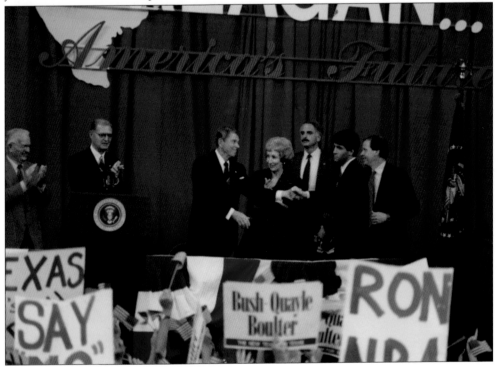

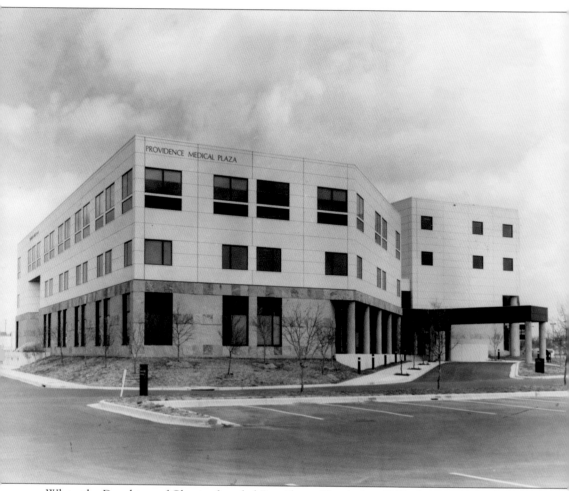

When the Daughters of Charity founded Providence Hospital in 1905, they established Waco's first hospital. More than a century later, the Providence Healthcare Network provides specialized and general healthcare services at locations all over Waco. In 1989, the Providence Medical Plaza opened for business near the intersection of Highway 6 and Highway 84. (BFPA.)

Four

THE 1990S TO 2015

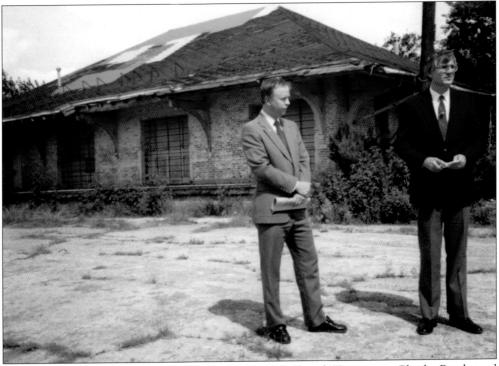

In this photograph from August 1990, Roy Walthall (left) and Waco mayor Charles Reed stand before a dilapidated former depot of the Missouri, Kansas & Texas (MKT or "Katy") Railroad, located in East Waco. The men were announcing a plan to renovate the depot as part of a comprehensive plan to revitalize the area. (BFPA.)

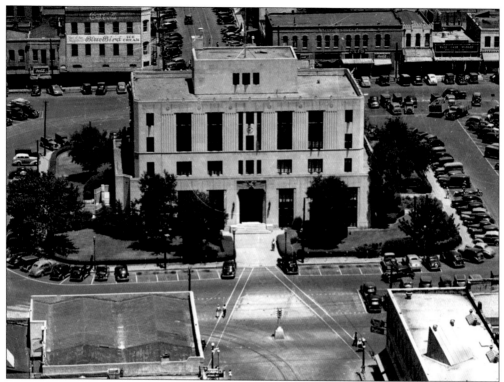

Waco's city hall was designed in the late 1920s by architect Harry L. Spicer and its Depression-era Art Deco style is unique among the notable buildings of downtown Waco. In the photograph above, city hall is still situated in the original town square, surrounded by storefronts (and public parking) on all sides. Over time, these buildings were demolished, and city hall became an island nestled next to the Waco Convention Center and Heritage Square. Fronted today by a fountain dedicated to the memory of longtime community boosters Carroll and Frances Sturgis, city hall remains the nerve center of the City of Waco's operations. (Above, RMML; below, author's collection.)

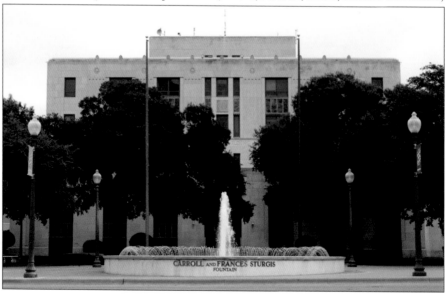

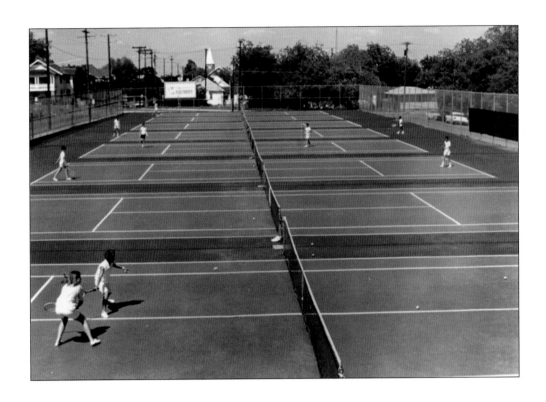

Reflecting the changing tastes in recreation between the 1970s and the year 2015, these two photographs depict the evolution of Sul Ross Park, located on Waco Drive at Fourteenth Street. In the image above, families play tennis on a series of clay courts that were maintained by the city for public use. Below, a newly opened skate park sits in the same location. Designed under the guidance of local skateboarding enthusiasts and open to the general public, the park offers skateboarders the chance to grind, ollie, jump, and handplant next to new playground equipment and a covered pavilion. (Above, GWCOC; below, author's collection.)

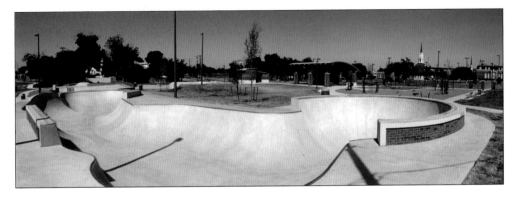

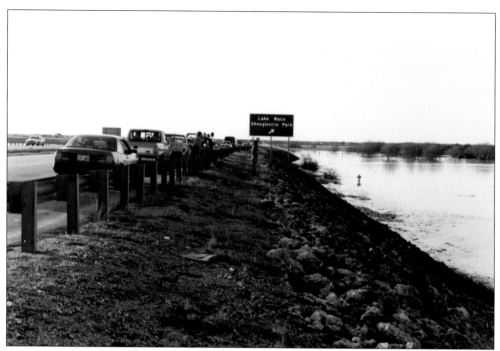

A major weather event in December 1991 lead the Bosque River, which feeds Lake Waco, to flood. The lake swelled to several feet above its normal levels, leaving areas like Speegleville Park underwater. These photographs capture both the impact of the storm in terms of property destruction and in public interest, as dozens of spectators pulled onto the shoulder at the end of the Highway 6 Twin Bridges to look at the destruction. The NOAA records for the event indicate that water levels topped out at 26.5 feet, one of the highest levels in the past 30 years. (Both, BFPA.)

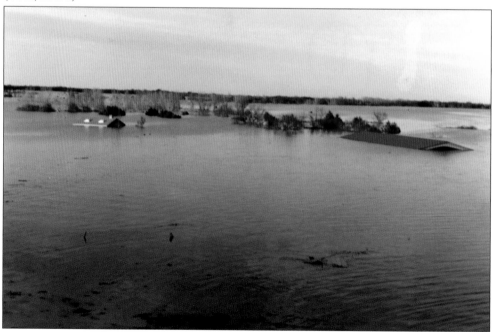

Born in the nearby suburb of Lacy Lakeview, Ann (Willis) Richards grew up in Waco and became only the second woman to hold the office of governor of Texas. She became famous for her sharp sense of humor, once famously quipping of George W. Bush that his gaffes were unavoidable because he had been "born with a silver spoon in his mouth." Above, Richards is seen with her constituents at an open government meeting in the early 1990s. She is pictured below speaking with a fellow graduate of Waco High School (from which she graduated in 1950). (Both, BFPA.)

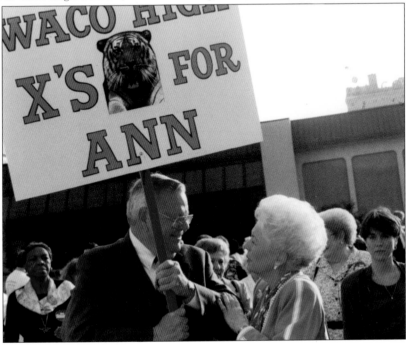

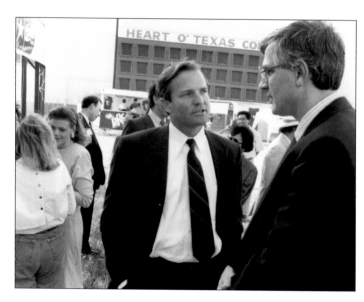

This 1992 photographs features two local political leaders: Chet Edwards (center) was a year into his first term as US representative (D-Waco) and Charles Reed (right) was completing his final year as mayor of Waco. Edwards went on to a distinguished career in public service, including serving as chair of the House Subcommittee on Military Construction, Veterans Affairs, and Related Agencies. (BFPA.)

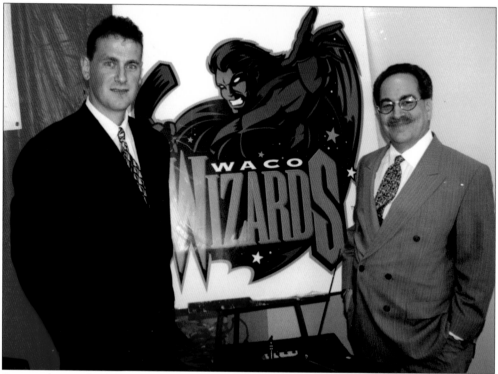

Semiprofessional ice hockey came to Waco in 1996 with the creation of the Waco Wizards franchise. The team, which existed from 1996 to 2000, was part of the now-defunct Western Professional Hockey League. Pictured here with the team's logo are Brad Trevling (left), director of hockey operations, and Rick Dames, owner. (BFPA.)

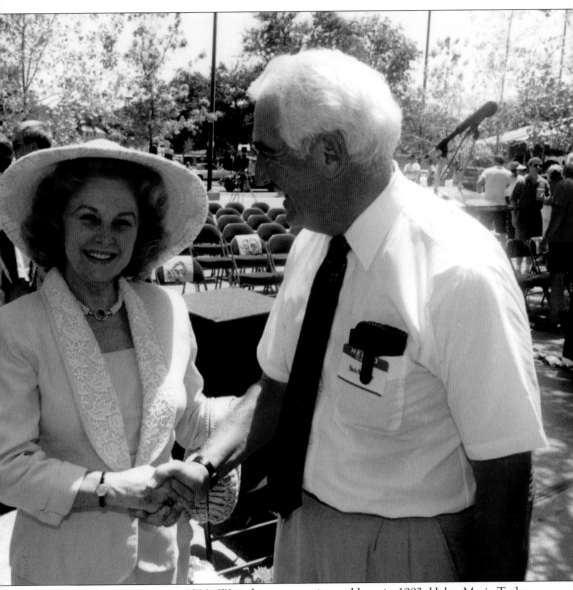

Two of the biggest names in 1990s Waco history are pictured here in 1992: Helen Marie Taylor and former mayor Bob Sheehy. Taylor, a native Wacoan, purchased a former school at 701 Jefferson Avenue and transformed it into the Taylor Museum of Waco History, which opened in 1993. Seeking to tell the story of Waco from its founding to the modern era, the Taylor Museum featured exhibits on the Cotton Palace Exposition and World War II hero Doris Miller. Its board dissolved in 1998, and the museum is currently only open by appointment. Sheehy served as mayor during the siege at the Branch Davidian compound, which lasted from February 28 to April 19, 1993. Sheehy was only a year into his tenure as mayor when the crisis erupted, and he was roundly praised for his efforts to keep the public informed while repeatedly telling the national media that the events were unfolding outside of Waco's city limits. (BFPA.)

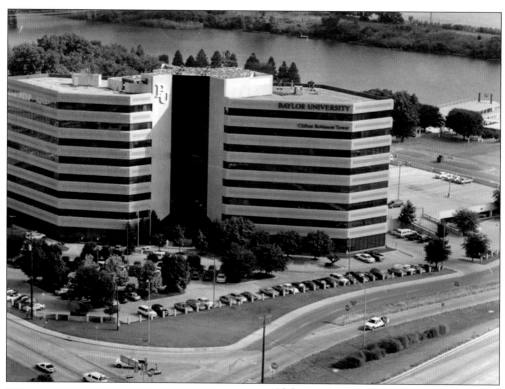

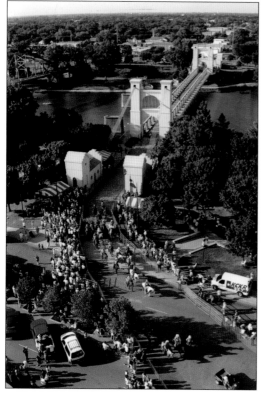

Clifton Robinson Tower, seen in this 1997 photograph, began life as University Towers and was renamed for a major benefactor after its acquisition by Baylor University in 1994. Today, its offices house many important university functions such as human resources, marketing and communications, development, and more. Paddle wheeler the *Brazos Queen* is seen at its dock on the Brazos River in the background. (GWCOC.)

Waco was founded in 1849, and a 150 years later, the city came out in a big way to celebrate its sesquicentennial. On June 26, 1999, the citywide celebration included a staged cattle drive across the suspension bridge, with 150 riders herding 40 longhorn steers toward downtown. (BFPA.)

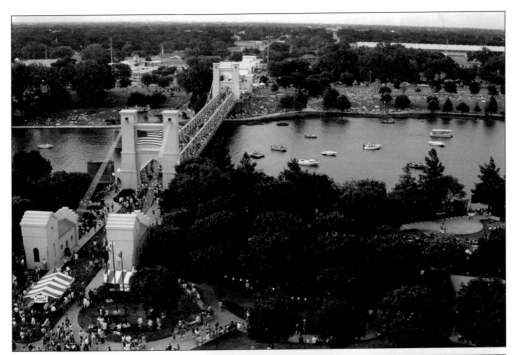

When Waco celebrated Independence Day in 1999, thousands turned out downtown to celebrate. The affair spilled onto both banks of the Brazos River, with revelers utilizing the historic suspension bridge to cross between downtown and East Waco, while boaters took advantage of good weather to party on the water. (BFPA.)

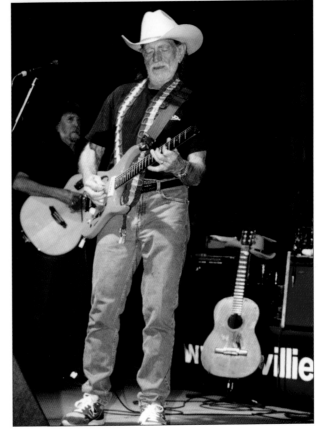

Born in the nearby town of Abbott, Willie Nelson has Waco roots as well; he attended Baylor University in the mid-1950s as a student studying agriculture. Over a six-decade music career, Nelson has become an outlaw-country icon, a political advocate, and a supporter of local history. He is seen here at a May 2001 concert stop in Waco. (BFPA.)

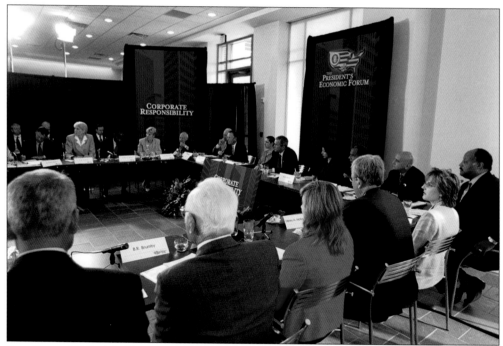

Pres. George W. Bush held an economic forum at the Baylor School of Law in October 2002, marking a major event in Baylor's history and an opportunity to showcase the university to a veritable who's who of politicians, business leaders, and academic colleagues. In this photograph, a breakout group discusses corporate responsibility. (National Archives and Records Administration.)

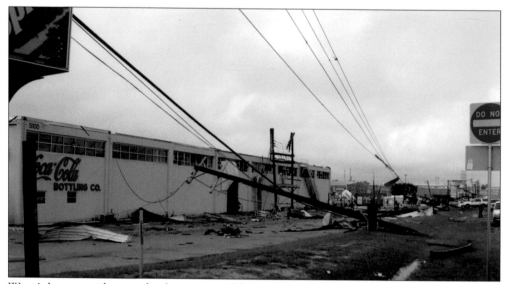

Waco's history with tornadic destruction added another chapter on May 6, 2006, when an F2 tornado caused widespread damage to the city. Most damage was concentrated on an area around the Coca-Cola Bottling Co. location on Franklin Avenue, where the roof was torn from the building, and bottles of soft drinks were thrown into the street. (BFPA.)

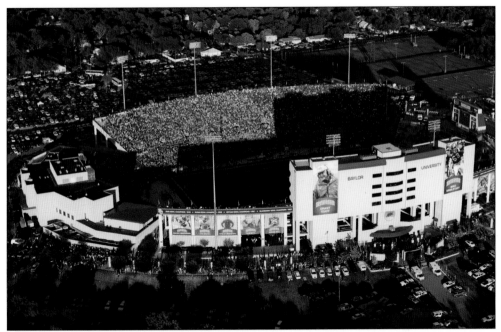

Floyd Casey Stadium became the home of Baylor Bears football in 1950 and served as home to incredible gridiron action until the opening of McLane Stadium in 2014. This photograph of the Case captures the stadium during the Baylor versus Texas A&M University game in 2006. (Baylor University Marketing and Communications.)

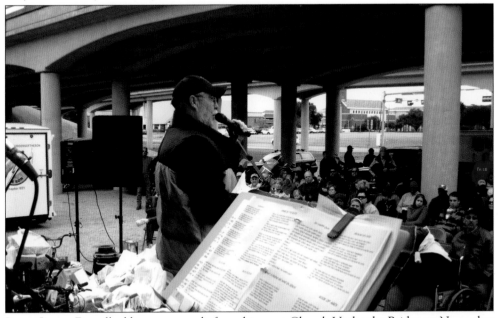

Pastor Jimmy Dorrell addresses a crowd of worshipers at Church Under the Bridge on November 30, 2008. Held every Sunday morning—come rain or shine—under the Interstates 35 overpass at Fourth and Fifth Streets, Church Under the Bridge is part of Dorrell's Mission Waco ministries and encourages a mutual worship service for low-income marginalized populations, local residents, and volunteers. (BFPA.)

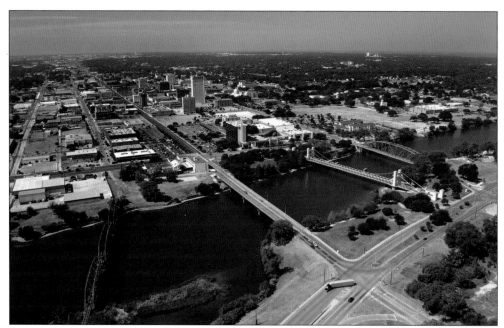

In many ways, these aerial shots of downtown Waco would look familiar to a visitor from the 1910s, as the major elements—the Brazos River, the ALICO Building, the suspension and iron bridges over the Brazos River—are the same as they were a century ago. But these photographs from 2006 also show the ways the city has grown, with new buildings, roads, and sports facilities sprouting up along the river's banks in the intervening century. Recent years have seen explosive growth in downtown lofts, restaurants, entertainment venues, and features like the Waco Downtown Farmers Market bringing new life to the city's core. (Both, GWCOC.)

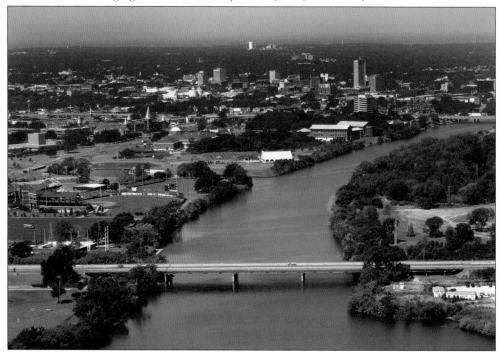

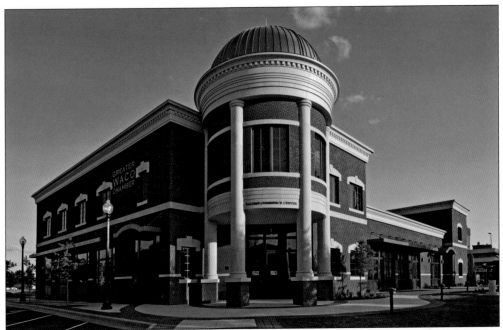

When the Greater Waco Chamber of Commerce opened its new headquarters in 2008, it quickly achieved LEED gold-level certification, making it the first certified green chamber building in America. Features like a rooftop garden, solar panels, and the use of furnishings made from sustainable sources make it an efficient building whose construction resulted in very little environmental impact. (GWCOC.)

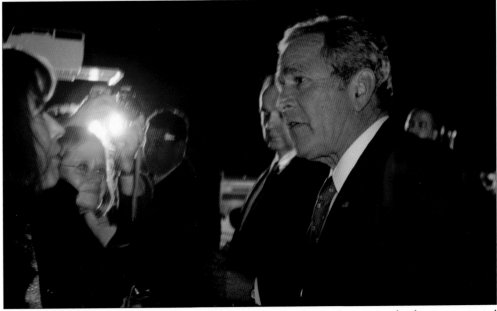

The glare of camera lights and a constant crowd of media, Secret Service, and aides accompanied Pres. George W. Bush when he flew into Waco to spend time at his Western White House in Crawford. This photograph from January 2009 catches him on the tarmac at TSTC, having arrived in town to, among other things, attend a Lady Bears basketball game. (GWCOC.)

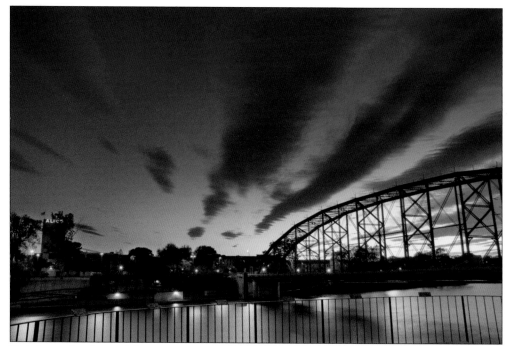

This is another beautiful sunset view of Waco, this time from the MLK Lookout on the Brazos River's east side. Situated on top of a piling for a long since demolished bridge, the lookout features a mural dedicated to the memory of Dr. Martin Luther King Jr. (Photograph by Jason Hagerup.)

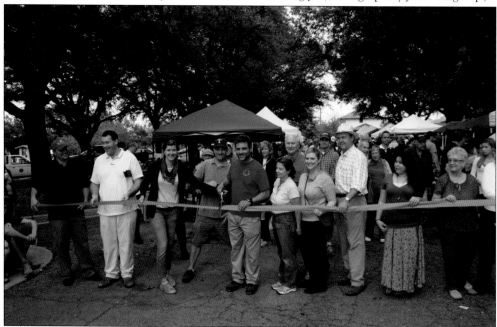

The Waco Downtown Farmers Market had its ribbon cutting on November 19, 2011. This photograph shows city dignitaries and its driving force, local farmer Terry Vanderpool (in the red T-shirt), marking its official beginning. The year-round Saturday market saw 2,000 visitors its opening weekend and continues to expand its fresh local offerings every season. (GWCOC.)

This unassuming row of warehouses occupied a block of University Parks Drive at its intersection with Franklin Avenue and was home to Brazos Machine Tools (right), Buzzard Billy's Cajun restaurant (center), and a space formerly occupied by an industrial concern (left). The block represented one of the last commercial/industrial sites on the Brazos River until the buildings were razed in 2012 to make way for a planned hotel complex. Those plans have been put on hold, but the space is currently home to a popular collection of food trailers whose offerings include Greek cuisine, pizza, burgers, and cupcakes. (Both, author's collection.)

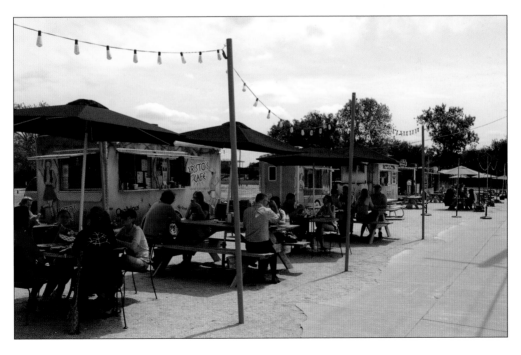

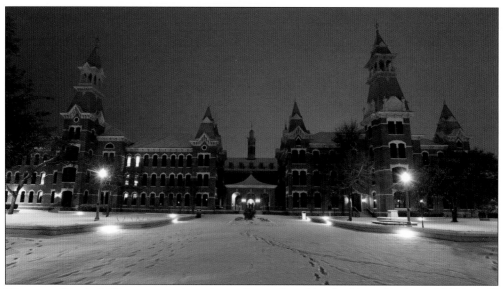

The core of Baylor's Waco campus is made up of two of its oldest buildings: Burleson Hall (at left) and Old Main (right); behind them is a later addition, Draper Academic Building. The buildings are part of picturesque Burleson Quadrangle, seen here in a dramatic snowscape in 2011. (Baylor University Marketing and Communications.)

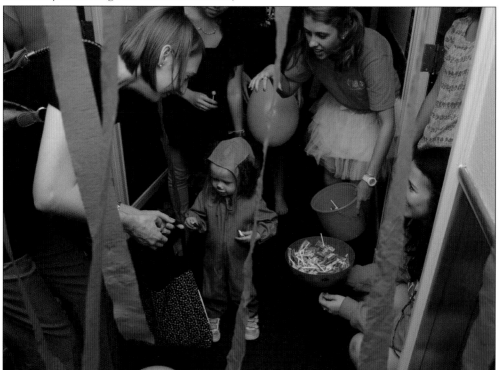

Baylor University has been named a "Great College to Work For" for many years, and its commitment to its employees includes events like the annual Treat Night held in campus residence halls. In this 2012 photograph, residents of Memorial Residence Hall pass out candy to the children of Baylor faculty and staff. (Author's collection.)

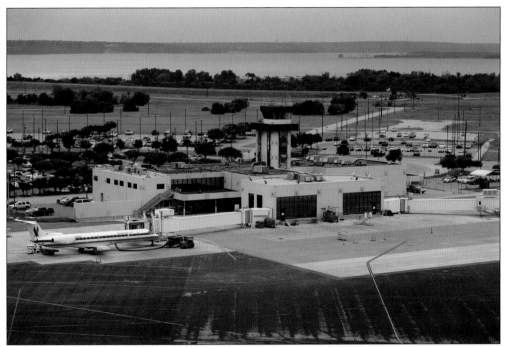

Situated near the shore of Lake Waco, the Waco Regional Airport is pictured here in 2012. The airport offers daily flights to Dallas-Fort Worth International Airport. The airport's roots date back to the 1940s, when it was built by the Army Air Corps as a location to train bomber pilots. (GWCOC.)

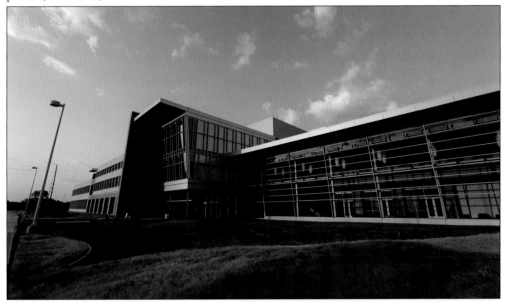

When Baylor University was looking for a way to encourage collaboration between its science disciplines and the private sector, it turned to an unlikely place: an abandoned tire factory. After a multimillion-dollar renovation, the new Baylor Research and Innovation Collaborative (BRIC) was born. This photograph from September 2013 shows the rejuvenated main facade of glass, brick, and steel. (Baylor University Marketing and Communications.)

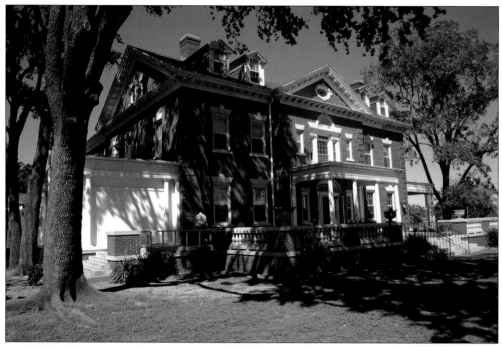

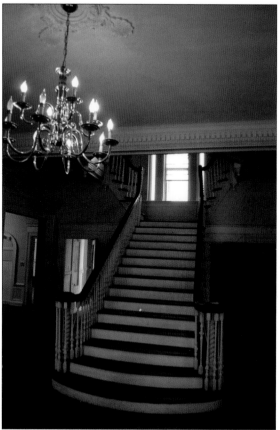

The Shear-Callan House, designed by Milton W. Scott and built in the early 1900s at 1401 Columbus Avenue, began life as a private home before becoming part of an in-treatment facility in the 1960s. In 2012, the house was sold to a private owner who made immediate plans to begin demolition. Local residents were angered at the plan, so the owner agreed to try a last attempt to find a new owner for the property. When the Shear-Callan House failed to attract a new buyer, its architectural elements were sold to the highest bidder, including the hand-carved banisters, chandelier, and plasterwork seen here in the home's main entryway. The orange tags in this photograph indicate which elements had already been spoken for by their new owners on October 14, 2012. (Both, author's collection.)

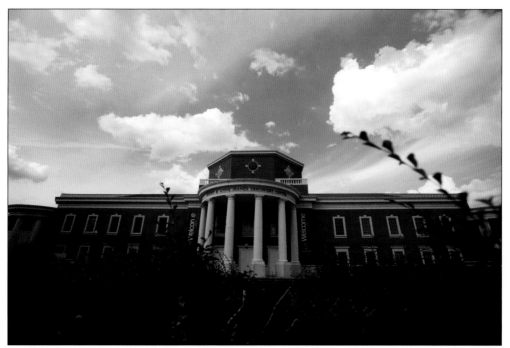

The Mayborn Museum Complex opened in 2004 on the Baylor campus and features exhibits that tell the cultural and prehistoric history of Central Texas. A family-focused museum, the Mayborn celebrated its 10th anniversary in 2014, with all 10 years under the leadership of Dr. Ellie Caston, a legendary figure in the Texas museum field. (Baylor University Marketing and Communications.)

The campus of Rapoport Academy occupies a number of buildings on the historic Paul Quinn College campus in East Waco. Grant Hall, pictured here on September 14, 2014, began life as a women's dormitory for Paul Quinn and was fully renovated for Rapoport's use as a multipurpose space that includes the Vance Dunnam Creative Arts Center. (Author's collection.)

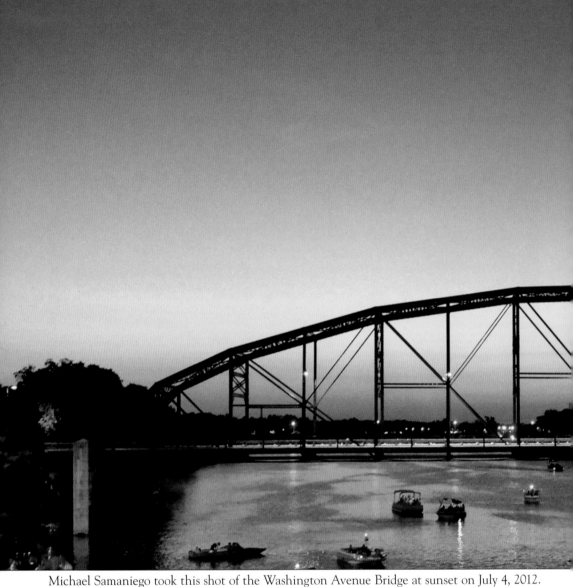

Michael Samaniego took this shot of the Washington Avenue Bridge at sunset on July 4, 2012. Against the backdrop of a pale purple sunset, boaters take advantage of the summer weather to find the best place to view an upcoming fireworks show. Waco's generally temperate climate affords residents and visitors alike hundreds of days a year to party on the Brazos River, national holiday or

not. The Texas Department of Transportation was awarded an excellence in preservation award by the City of Waco's Historic Landmark Preservation Commission for its work restoring the bridge in 2011 to restore it and its original black paint scheme. (Photograph by Michael Samaniego.)

Nancy Grayson, longtime advocate for redevelopment in East Waco, is pictured here in September 2014 cleaning the sidewalk in front of her restaurant and bakery, Lula Jane's. Grayson used repurposed bricks from a building that was being demolished on Elm Avenue to construct her establishment, which focuses on locally sourced ingredients and scratch-made treats. (Author's collection.)

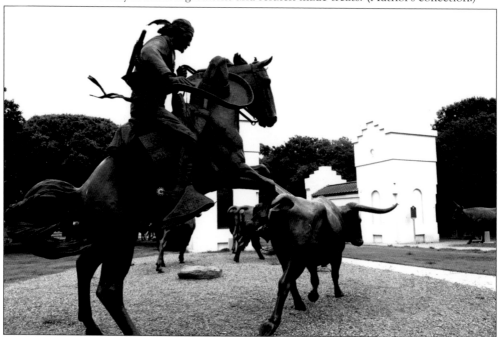

A large outdoor bronze installation circles the downtown side of the Waco Suspension Bridge. Comprised of three cowboys—Anglo, Hispanic and African American—and a herd of bronze longhorns, the installation was designed by artist Robert Summers. The statues pay homage to Waco's history as part of the Chisholm Trail. (Author's collection.)

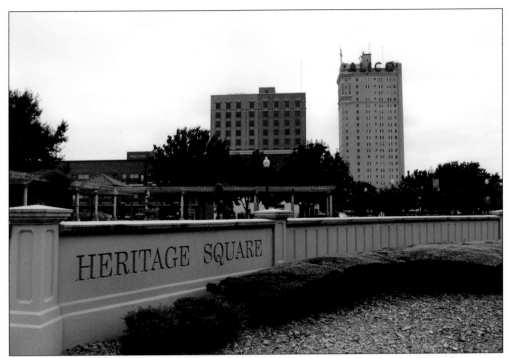

Heritage Square lies directly across North Third Street from city hall. Opened in 2001, the current incarnation of Heritage Square features covered walkways and plaques honoring important Wacoans, including each of the city's former mayors. In this photograph are, from left to right, the Waco ISD building, Roosevelt Tower, and the ALICO Building. (Author's collection.)

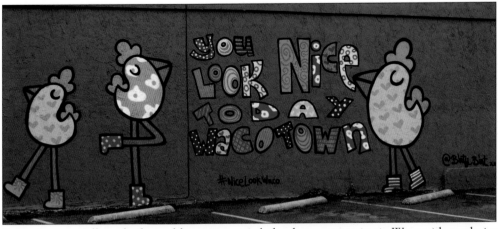

Street art, especially in the form of downtown murals, has begun appearing in Waco with regularity in recent years. This piece, on the side of a downtown dry cleaner's shop, was created by UK-based street artist Binty Bint, whose colorful chickens and catchphrase "You Look Nice" pair well with one of the city's newest nicknames, Wacotown. (Author's collection.)

Not many towns can boast a century-old monument, let alone a semi-forgotten one that honors the 300th anniversary of William Shakespeare's death. Tucked into a secluded corner of Cameron Park, the monument was erected by the Waco Shakespeare Club in 1916. The club chose the spot because, according to the plaque, Shakespeare and "nature are but one." (Author's collection.)

Baylor University's Diana R. Garland School of Social Work moved into this complex of buildings in downtown Waco in late 2010 after extensive renovations to the mid-century buildings that had previously housed Wells Fargo Bank. The move to downtown was undertaken to better connect students in the program with city services and the clients who use them. (Author's collection.)

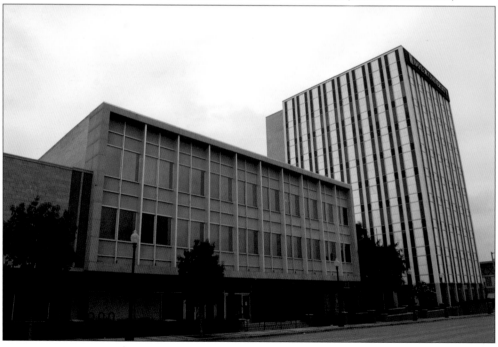

In the historic Oakwood Memorial Cemetery stands a memorial to Waco's proud firefighting tradition. It is the only memorial in the cemetery to feature painted elements—the firefighter's red helmet and portions of the hydrant are frequently refreshed—and it is a prominent feature of the cemetery's northwest corner. (Author's collection.)

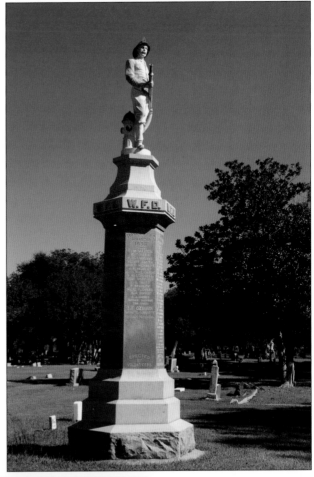

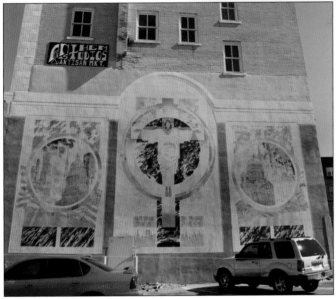

This mural on the Austin Avenue side of the Praetorian Building in downtown was painted by a visiting Russian artist and features iconography with both American and Russian elements. The central element, a three-story image of Jesus Christ, bears the inscription "Not Only For Us," written in English and Cyrillic; this was the motto of the Praetorian Insurance Company, which erected the building in 1915. (Author's collection)

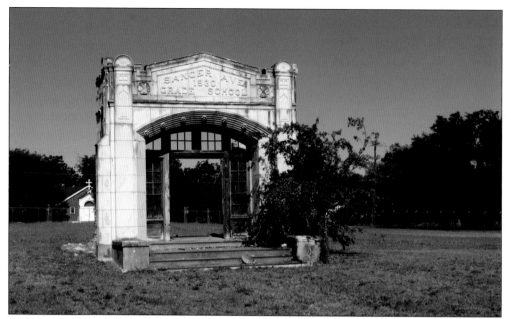

This ornate entryway, standing alone in the middle of a city block off Waco Drive at Eighteenth Street and Sanger Avenue, is all that remains of the Sanger Avenue School. The majority of the school, built by noted Waco architect Milton W. Scott in 1904, was heavily damaged in an arson fire in 2008; it was finally demolished in 2010. (Author's collection.)

The lobby of McLennan Community College's science building features a magnificent stained-glass installation created by the artists at Stanton Glass Studio of Waco. The piece, titled *The Geometry of Growth*, is intended to represent students' burgeoning understanding of the world that comes with greater education. (McLennan Community College Archives.)

This building on Austin Avenue was originally the home of Waco's S.H. Kress & Co. five-and-dime store. Today, it is the home of the Kress Lofts (upstairs) and Jake's Texas Tea Room. Next door is Woolworth Suites, another loft development with retail space below. These buildings are part of a wave of loft and retail remodels taking place downtown. (GWCOC.)

The former home of an office-supply company was renovated in 2013 by builders Sorrels and Gunn into several luxury lofts. Two features of the building are its preserved advertisement for a long-lost hardware and clothing store and the so-called "hobbit" door that lets into a garden fronted on the south by the Hippodrome Theatre. (GWCOC.)

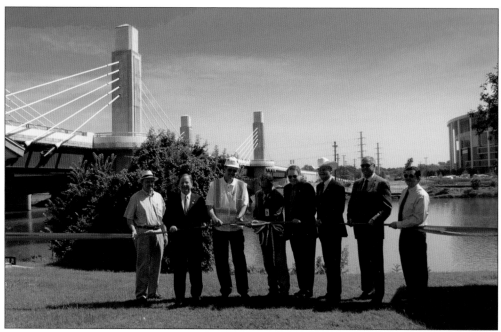

Since its creation in the mid-1960s, Interstate 35 sported just a pair of bridges across the Brazos River. Those original lanes were prone to backups and standstills when accidents up or down the highway caused traffic to slow. In 2014, that problem was remedied with the opening of two new bridges. These photographs were taken during the ceremonies celebrating their completion. Lane Construction (whose crew is pictured here) did the work, and dignitaries such as Mayor Malcolm Duncan (far left), Rep. Bill Flores (next to Duncan), and Congressman Doc Anderson (in cowboy hat) were on hand to celebrate. (Both, GWCOC.)

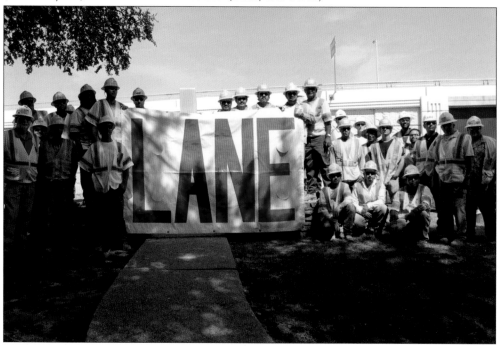

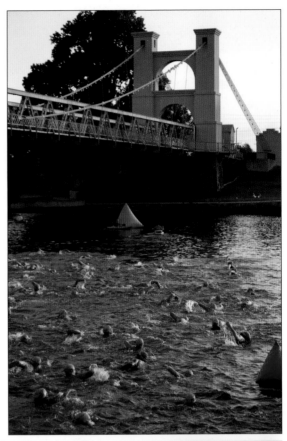

When the leading lights of Waco envisioned a bridge across the Brazos River during the uncertain days of Reconstruction, they probably could not have imagined hundreds of athletes swimming, biking, and running in its general vicinity almost 150 years later. But that is exactly what happens at the annual TriWaco, where triathletes compete in activities centered around the suspension bridge, including a swim (pictured on the right) and a finish line at the end of the bridge, captured during the 2014 race. Recent decades have seen countless events either staged on or finishing at the bridge, which makes for a dramatic final backdrop to a race well run. (Both, GWCOC.)

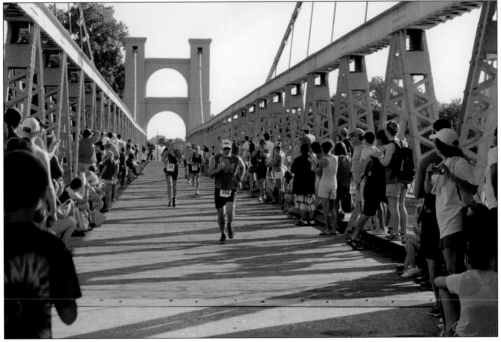

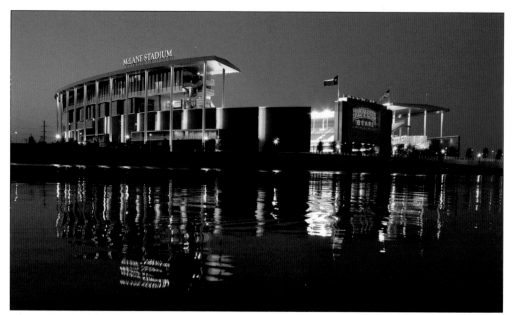

The sports world's attention was drawn to Waco in a major way with the opening of McLane Stadium, a $260-million riverfront facility that hosted its first game against Southern Methodist University (SMU) on August 31, 2014. This stunning night shot was taken just a few weeks prior. Baylor won every one of its home games during the inaugural 2014 season. (Baylor University Marketing and Communications.)

Two of Baylor's proudest traditions—athletics excellence and community spirit—are united in a unique celebration featuring Pat Neff Hall, the campus's main administration building. After every Baylor athletics victory, the tower of Pat Neff Hall is painted with green light, signaling to all of Baylor Nation that the Bears achieved another win. (Baylor University Marketing and Communications.)

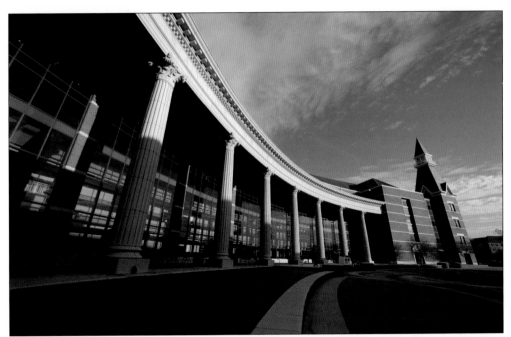

The largest building on the Baylor campus is the Baylor Sciences Building (BSB), home to programs such as biology, chemistry and physics. The $100 million building has more than 500,000 square feet of space with labs, lecture halls, and offices. The facility also features a large fountain and a creek-style water feature. (Baylor University Marketing and Communications.)

Photographer Graham Dodd captured this image of a concert in the backyard-style setting of Common Grounds, a local coffee shop that has been a staple of the Waco caffeine scene since 1994. Located in a former residence just across Eighth Street from the Baylor campus, it is popular for its unique drinks and intimate performance venue, which draws local and national acts. (GWCOC.)

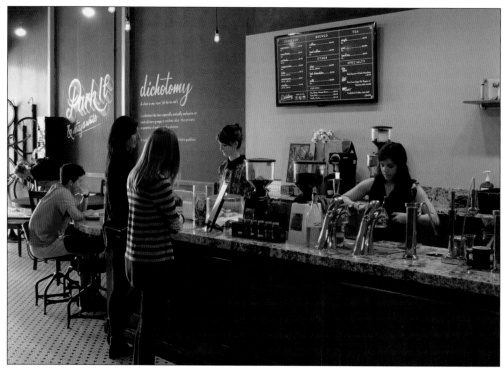

Waco's entrepreneurial spirit gives business owners plenty of freedom to experiment with new concepts, like the aptly named Dichotomy Coffee and Spirits. Housed in a renovated storefront in downtown across from the McLennan County Courthouse, Dichotomy offers coffee drinks in the morning and cocktails, liquor, and beer in the evening. (GWCOC.)

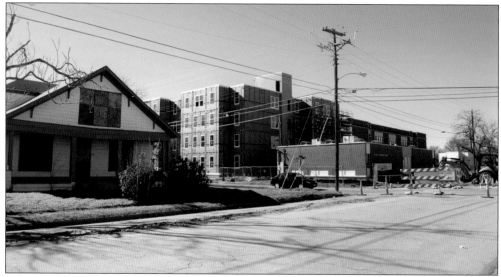

This 2015 photograph of the intersection of South Eighth Street and Cleveland Avenue captures the spirit of renewal underway in this crucial area along the Interstate 35 corridor. A development company is renovating the former Sul Ross Elementary School and the adjoining Waco ISD Alternative Campus into the West Campus Lofts, high-end housing aimed at Baylor students. (Author's collection.)

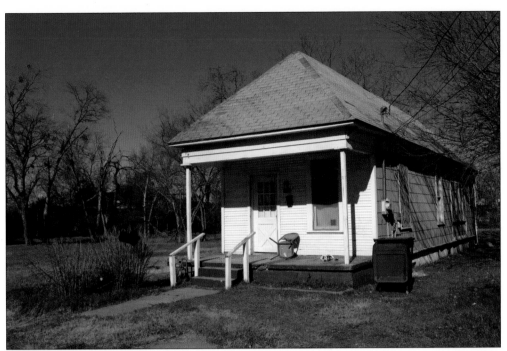

The humble shotgun house, once a staple of modest neighborhoods around Waco, exists in only a few locations today. Above is a single-family home at 816 South Seventh Street, one of the few remaining unmodified shotgun houses in town. Below is the Dutton Street Mission Church, an example of a shotgun-style building modified for a nonresidential use. In 2012, Waco's Historic Landmark Preservation Commission awarded the owner of a third shotgun house at 1111 Ross an award for Excellence in Residential Restoration. It is hoped that this kind of recognition will spur other homeowners to preserve and restore the remaining stock of Waco's shotgun houses. (Both, author's collection.)

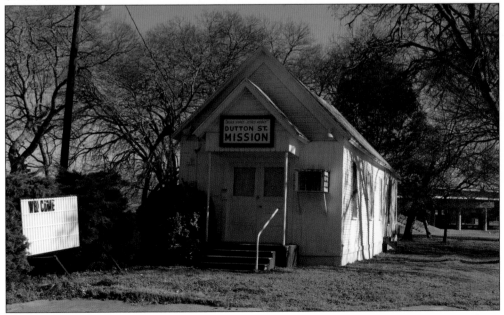

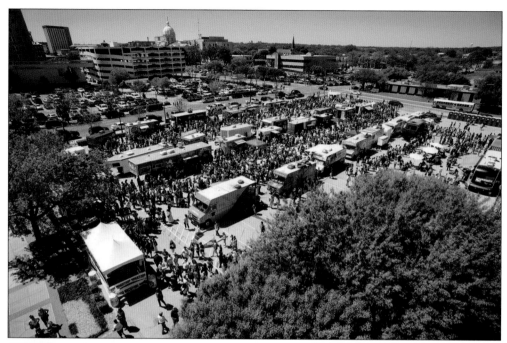

On March 28, 2015, three dozen food trucks descended onto Heritage Square in downtown Waco for the inaugural Texas Food Truck Showdown. Featuring cash prizes and voting by both the public and a panel of celebrity judges, the event drew thousands of foodies, as evidenced by this aerial drone photograph. (GWCOC.)

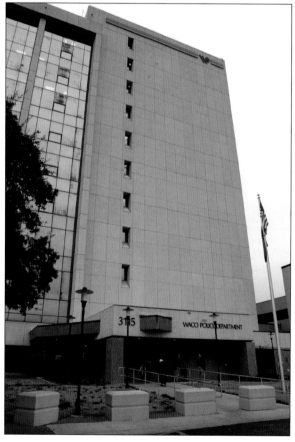

When the Waco Police Department outgrew their headquarters at 721 North Fourth Street after 43 years, they relocated to the former Hillcrest Medical Tower at 3115 Pine Avenue in 2013. The 10-story building, seen in this January 2015 photograph, was purchased by the City of Waco after voters approved a bond package in 2007. (Author's collection.)

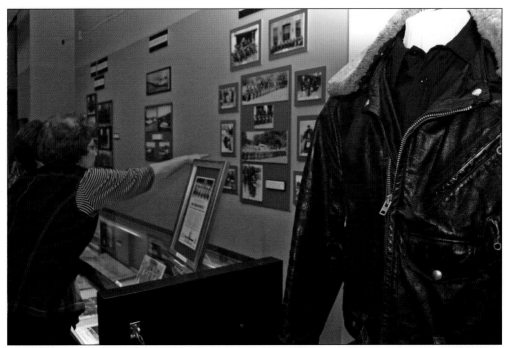

The Waco Police Museum, which began under the guidance of Sgt. Randy Lanier in 2010 as an effort to preserve the history of the department, held an opening reception for donors and supporters on January 21, 2015. In this photograph, attendees view artifacts and images from the motorcycle police squad. (Author's collection.)

The *Waco Tribune-Herald* is the Waco area's daily newspaper of record, and its roots in the community date back to the 1892 *Waco Evening Telephone*. Its headquarters on Franklin Avenue are seen here in this August 2015 photograph. The paper won praise and significant national attention for its coverage of the Branch Davidians and the ensuing siege at Mount Carmel in 1993. (Author's collection.)

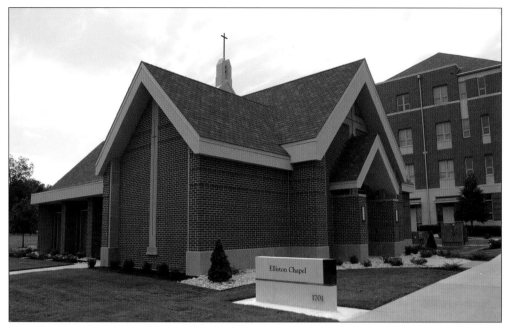

Completed in the spring of 2015, Elliston Chapel is one of the newest buildings on the Baylor University campus. The building represents a sacred space open to the entire campus community, described by the university's chaplain as "everyone's chapel." It was named in honor of alumna Molli Elliston and her husband, Gary. (Author's collection.)

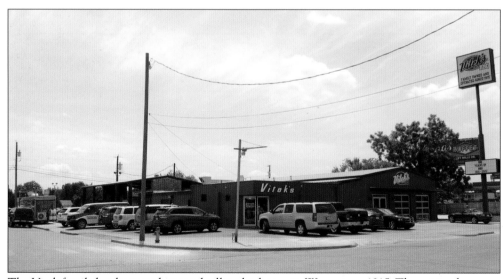

The Vitek family has been making and selling barbecue in Waco since 1915. The original grocery building, in the middle of this 2015 photograph, was expanded with additional seating and a covered beer garden in 2007. In 2013, he restaurant's signature dish, called the GutPak, was chosen America's Best College Eat by voters on the Cooking Channel's website. (Author's collection.)

In what is likely its last published photograph, taken before falling to demolition in 2015, the former Weston Biscuit Company factory stands vacant at the corner of Franklin Avenue and Twentieth Street. In the 1950s, the location made cookies for the Girl Scouts; by the 1980s, it had become home to a box factory. (Author's collection.)

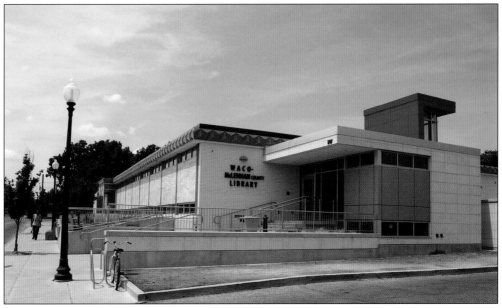

The downtown branch of the Waco-McLennan County Library was originally built in the early 1960s. Its large pink marble panels and unique geometric cornice were retained during a major renovation that was completed in 2013. The signature red cupola, new windows, and enhanced interiors marked a new chapter in the life of this downtown landmark. (RMML.)

A century-old warehouse at South Sixth and Mary Streets that once housed the Waco Dry Goods Company had been home to the Gradel Printing since 1995 when it was announced in 2015 that local developers Shane and Cody Turner purchased the building. They plan to renovate it into luxury lofts under the name Altura. (Author's collection.)

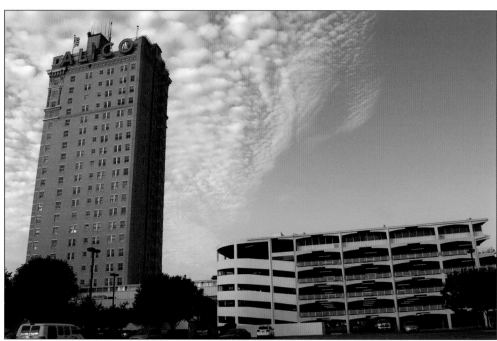

Perhaps no building is more associated with Waco than the Amicable Building, known for decades as the ALICO after the acronym for its original tenant (and the large neon letters found at its roofline). A renovation in the mid-20th century included the attached parking garage and a short-lived hotel, but it is the building's height and 100-plus years of history for which it is beloved by locals. (Author's collection.)

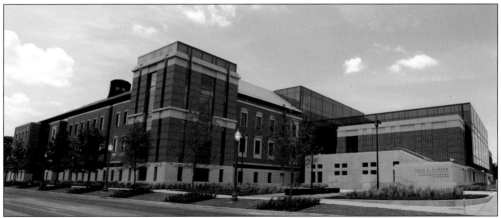

Baylor's Hankamer School of Business moved into its new home in the Paul L. Foster Campus for Business and Innovation in time for the start of the fall 2015 semester. The campus expands the school's square footage by nearly 40 percent and features the latest in classroom technology, a 350-seat auditorium, dining options, and unique architectural features. (Author's collection.)

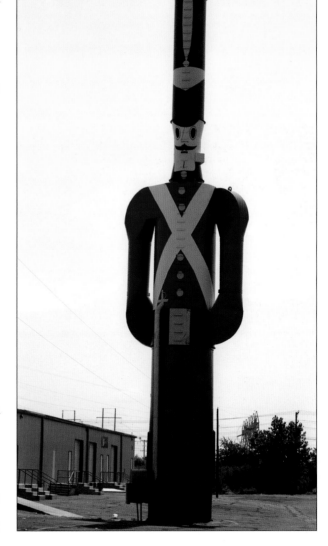

The toy soldier that stands tall near the intersection of US Highway 84 and Highway 6 began its life as an incinerator for a furniture company, but since the fall of 2014, it has become a local landmark in its own right. Now, the Soldier Office Warehouses utilize it as both an advertisement and a conversation starter for the community. (Author's collection.)

What started as a small antiques and home-decor business founded by Chip and Joanna Gaines of Waco turned into a national television phenomenon when the pair became stars on the HGTV show *Fixer Upper*. The original Magnolia location on Bosque Boulevard is seen in the photograph above. The Gaineses purchased the century-old Brazos Valley Cotton Oil facility in 2014, and they immediately began converting its processing shed (left), office (center), and iconic silos (right) into Magnolia Market, where they plan to provide shoppers with unique home goods, food trucks, antiques, and more. It opened in October. (Both, author's collection.)

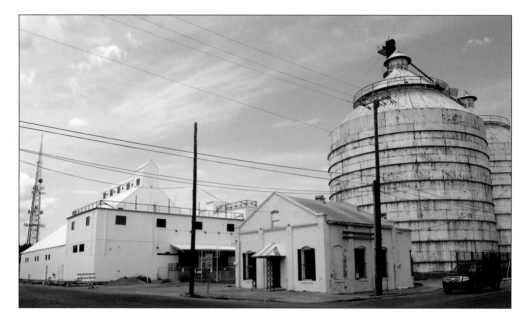